AT HOME
with the
SOANES

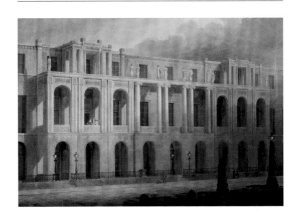

UPSTAIRS, DOWNSTAIRS
IN 19TH CENTURY LONDON

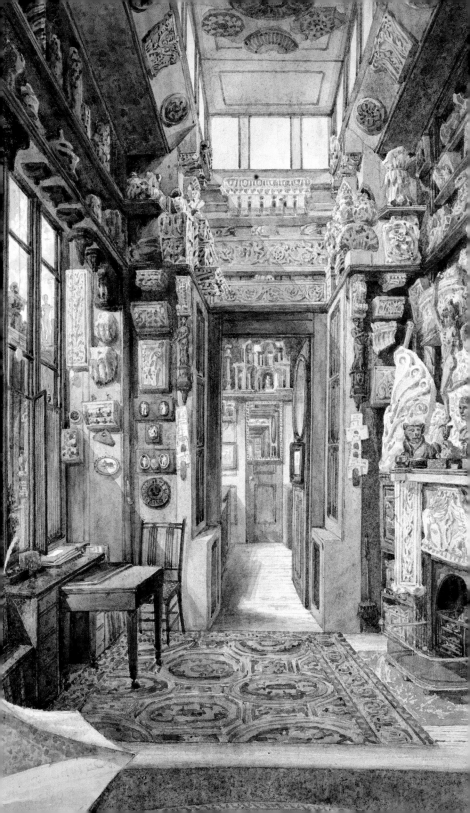

AT HOME
with the
SOANES

UPSTAIRS, DOWNSTAIRS
IN 19TH CENTURY LONDON

SUSAN PALMER

PIMPERNEL
PRESS LTD
www.pimpernelpress.com

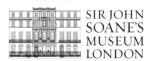
SIR JOHN
SOANE'S
MUSEUM
LONDON

CONTENTS

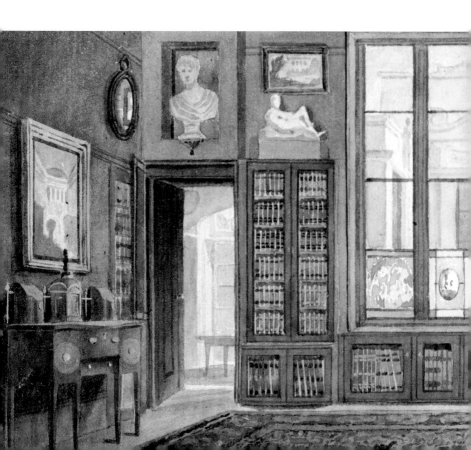

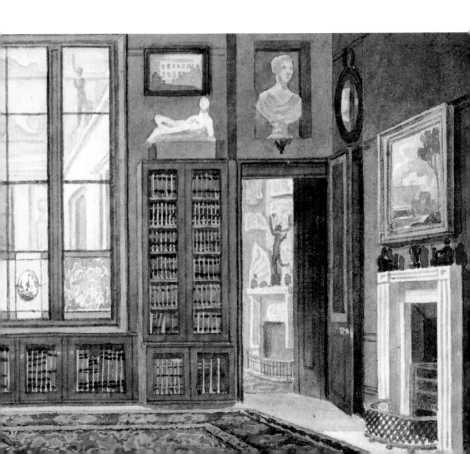

At Home with the Soanes

First published in Great Britain 1997 by Sir John Soane's Museum
This edition published by Pimpernel Press Limited 2015
www.pimpernelpress.com

Text & illustrations © The Trustees of Sir John Soane's Museum
unless otherwise noted on pages 108–111

Sir John Soane's Museum Reg. Charity No. 313609
978-1-9102-5844-6

Typeset in Apolline

Front cover illustration: Detail from a design by Soane for the façade of Nos 13–15 Lincoln's Inn Fields, 1813. Soane and his wife are depicted on the balcony of No.13 (the closed-in loggia was not created until 1834) dressed for an evening entertainment. Note Mrs Soane's turban to match her dress, complete with feather, and her necklace and earrings.
Back cover illustration: View from the North Drawing Room looking towards the South Drawing Room, c.1834
Half-title page: Design by Soane for the façade of Nos 13–15 Lincoln's Inn Fields, 1813
Title page View of the Study, 1822
Contents: Detail from a view of the Dining Room, 1825

ABBREVIATIONS

c.: circa	n.d.: not dated	£: pound(s) (see below)
cwt: hundredweight	oz: ounces	s: shilling(s) (see below)
d: pence (see below)	p.: page	/-: shilling(s) (see below)
°F: degrees farenheit	Pl.(s): Plate(s)	yd(s): yard(s)
doz.: dozen	lb(s): pound(s) (weight)	

NOTE ON PREDECIMAL CURRENCY AND PRICES

Before the present decimal system of currency was introduced in Great Britain in 1971 a system had operated for centuries in which there were twelve pennies in a shilling and twenty shillings in a pound. This was expressed as £ s d, or pounds shillings and pence (l s d or *librae, solidi* and *denarii* being Latin for pounds, shillings and pence). Amounts were expressed thus: £3.8.6, i.e three pounds, eight shillings and sixpence. Shillings could be expressed as eg. 6s or 6/-, and shillings and pence as eg. 6s 6d or 6/6. Pennies were further divided into two halfpennies, which were themselves divided into two farthings. Twenty-one shillings, or one pound and one shilling was known as a guinea, two guineas being two pounds and two shillings, and so on.[1]

1. Anyone interested in finding out more about pre-decimal currency, and about pre-metric systems of weights and measures, is recommended to consult Colin R. Chapman *How Heavy, How Much and How Long? Weights, Money and other Measures used by our Ancestors,* Lochin Publishing, 1995. Two websites that calculate the present worth of a sum of money at a given date in the past are: http://apps. nationalarchives.gov.uk/currency/default [not updated since 2005] and http://www.measuringworth. com/calculators/ppower

INTRODUCTION

'AT HOME ALL DAY destroying letters and papers', wrote Soane in his diary on 22 January 1832, from which one might conclude that there would be little to detain an archivist at Sir John Soane's Museum. Nothing, however, could be further from the truth – Soane may not have kept absolutely everything, but a large body of material has survived, and one which touches upon almost every facet of his personal and professional life.

Amongst this are a large number of bills relating to the purchase of clothes and other personal items, and also to the running of the house, the purchase of food and the employment of servants. Put together with the diaries kept by both Soane and his wife, evidence from the correspondence with friends, observations from contemporaries such as Joseph Farington RA, and the watercolours of the interiors of the house made by Soane's pupils at various dates, all these enable a vivid picture to be built up of the Soanes' domestic life.

This book is written for those interested in the domestic lives of the past as well as for the visitor to the house who has been excited by Soane's innovative architecture and fascinated by the objects in his collection, but is left with questions, such as 'Where did they sleep?', 'What did they eat?' and 'How many servants did they have?'. It is hoped that this book will provide at least some of the answers. It does not claim to break new ground in research into domestic history, but rather to put the Soane family into their domestic setting, and to show that however innovative and pioneering Soane's architecture may have been, in their domestic life they conformed very largely to the standard pattern of the day for a family of their class and situation.

It was, however, a domestic life played out against a less than ordinary setting. The interior of No. 13 Lincoln's Inn Fields was one of the most eccentric interiors in London at the time, and both houses were periodically thrown into confusion by building work and by additions to the collections and new ways of displaying them. From 1812, too, the Soanes were living in a semi-public house, as Soane had declared his Museum open to students and others to come and see and be inspired by his collections, and it is mentioned in Hughson's *Walks Through London* of 1817. It was no doubt with some understanding of all of this that Arthur Bolton, Curator of the Musuem from 1917 to 1945, dedicated his edition of Soane's correspondence, *The Portrait of Sir John Soane, R. A.*, published in 1927, to 'Those who are, and all who will be, Wives of Architects'.

Twenty years have passed since this book was first written, during which a number of discoveries have been made during the extensive restoration works which have been carried out on the building, culminating in the recreation of the lost private apartments on the second floor – Soane's Bedroom and Bathroom, the Model Room and Mrs Soane's Morning Room. The opportunity has been taken to reflect these discoveries in this revised and newly-designed edition, the publication of which will mark the opening of the private apartments.

Susan Palmer
December 2014
12 Lincoln's Inn Fields

LIFE BEFORE LINCOLN'S INN FIELDS

Portrait of Mrs Soane, John and George by Van Assen, c.1800.

BORN IN 1753, THE youngest son of a Berkshire bricklayer, John Soane attended a good school in Reading, and coming to London at the age of fifteen to learn to become an architect, worked first of all in the office of George Dance the Younger and then for Henry Holland. This practical experience was supplemented by studying Architecture at the Royal Academy of Arts, where in 1776 he won the Academy's gold medal for his design for *A Triumphal Bridge*. He was also awarded a travelling scholarship that enabled him to make his Grand Tour on the Continent. The two years from 1778 which he spent abroad, chiefly in Italy, were very influential on his later architecture, and were also the means of introducing him to several patrons and future clients.

Back in England once more in 1780, the twenty-seven-year-old Soane rented rooms at 10 Cavendish Street and set about building up his architectural practice. Through George Dance, his old master, he became acquainted in 1783 with George Wyatt who was Surveyor of Paving to the City of London Corporation

and a man of some consequence in the London building world, besides owning a considerable amount of property. By the beginning of 1784 it is clear from the entries in his diary that Soane was much struck by George Wyatt's niece, Elizabeth Smith, who kept house for him, both her parents having died. Dinners or visits to the theatre or to Vauxhall Gardens in her company are recorded with increasing frequency, and on 21 August 1784 they were married at Christ Church, Lambeth.

They set up home in the rented apartments to which Soane had moved in 1781: the first floor and a front room upstairs of 53 Margaret Street, off Cavendish Square. Here they were joined later in the year by Soane's first pupil, John Sanders. He was, in fact, the only one of the pupils over the years to

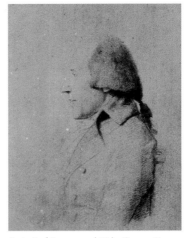

Portrait of Soane aged 43 by George Dance the Younger, 1795. Wigs with queues or pigtails were fashionable until the end of the eighteenth century.

live in and have his meals provided. Here too their first son, John, was born, on 29 April 1786. In the November of the same year they moved to 77 Welbeck Street, of which Soane purchased the lease. A second son having been born in December 1787 but having only survived six months, John junior was joined by another brother, George, on 28 September 1789.

In February of 1790, George Wyatt, Mrs Soane's uncle, died, leaving them a considerable amount of property which produced an income in the form of annual rents. Shortly afterwards Soane set up an office for his architectural practice at Albion Place, Blackfriars, in one of the houses there which had belonged to George Wyatt. Apart from an office at the Bank of England, where he had been appointed Architect and Surveyor in 1788, this seems to have been the first office he established separately from his house. Albion Place was probably a temporary measure while he was winding up his wife's uncle's estate, for in April 1791 he moved his office to Great Scotland Yard. Here it was to remain until the move to Lincoln's Inn Fields.

The legacy of 1790 had increased the couple's income considerably and was sufficient to consider buying the freehold of a bigger house. Accordingly on 30 June 1792 Soane purchased No. 12 Lincoln's Inn Fields from a Mrs Barnard for £2,100. He then proceeded to demolish the mid-seventeenth-century house on the site and rebuild it to his own designs. Two years later on 18 January 1794 Mr and Mrs Soane and their young family moved in to the newly-completed house.[2]

2. For a fuller account of this period of Soane's life the reader is referred to Gillian Darley *John Soane an Accidental Romantic*, Yale University Press, 1999.

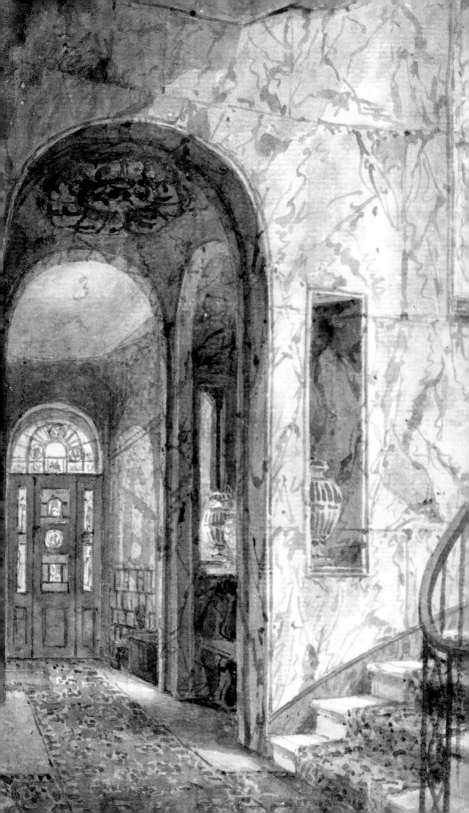

1

THE HOUSES AND
THE HOUSEHOLD

THE NEIGHBOURHOOD

No.12 LINCOLN'S INN FIELDS was situated in the middle of the north side of a large square which had houses around three of its sides and was bounded on the fourth by the wall of Lincoln's Inn (see below). The houses were largely occupied by middle class professional men, a number of whom were lawyers. In the centre of the square was a railed garden, with grass interspersed with gravel walks, and planted with trees and shrubs (see page 12). All the householders in the square had a key to these gardens, the gates otherwise being kept locked.

The square had been run since 1734, like many similar London squares, by a board of Trustees, set up under an Act of Parliament, and elected from amongst the inhabitants (Soane himself was later to become one). All the owners of property in the square paid an annual rate to the Trust, and from this were funded the upkeep of the paving and the central garden, and the employment of a lamplighter, a gardener, a scavenger to keep the carriage and footways clean and to take away rubbish from the houses, a beadle to keep the peace and watchmen to protect the inhabitants and their houses at night.

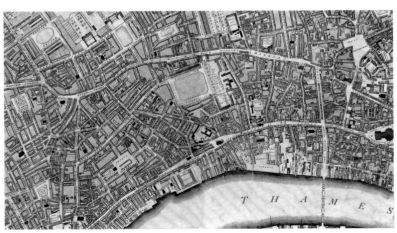

ABOVE Part of Horwood's map of London of 1799, showing Lincoln's Inn Fields and the surrounding areas.
LEFT View of the Entrance Hall, c.1825.

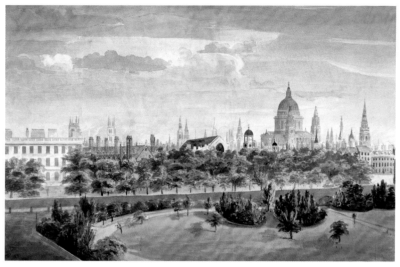

View of London from the top of No.13 Lincoln's Inn Fields, drawn by Robert Chantrell, one of Soanes's pupils, 1813. In the foreground can be seen part of the enclosed gardens in the middle of the square.

THE HOUSES

The new house at No.12 comprised a Front and Back Kitchen and associated offices in the basement, a Dining Room and Breakfast Room on the ground floor, Drawing Rooms on the first floor and two floors of Bedrooms above. At the very top were garrets which much later, in 1826, when Soane was no longer living in the house (see below) were made into another complete storey. On the ground floor behind the Breakfast Room, where the stables and outbuildings would originally have been, was a Drawing Office where his pupils would work.

Fourteen years later in 1808 he was able to expand the house a little by buying the freehold of No.13 Lincoln's Inn Fields next door. He continued to rent the main house to the occupant, a Mr George Tyndale, but by demolishing the stables and outbuildings at the back of the site was able to build a new office and a domed double-height tribune, lit by a skylight, for the display of plaster casts, which formed the very beginnings of his Museum. Three years later in 1811 he persuaded his neighbour to do a swap: Mr Tyndale moved into No.12, which he rented from Soane, and Soane was able to pull down and rebuild No.13. They moved into the completed house on 11 October 1813, and Soane continued to live

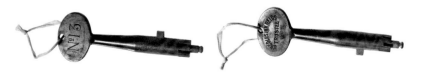

Soane's key to the Lincoln's Inn Fields gardens.

there until he died in January 1837. Sadly Mrs Soane only enjoyed the new house for two years, as she died in November 1815.

The new house followed much the same pattern as the previous one, although the site was a little bigger, and across the back of it ran the Museum and adjoining architectural office. Over the succeeding years Soane made a number of alterations to it, and gradually the Museum element, particularly in the basement, took over some of the space previously taken up by domestic offices. In 1823 he purchased No.14 Lincoln's Inn Fields, the adjoining house on the other side, and again pulled down the existing house and rebuilt it. He then rented out the main house to a firm of solicitors, but at the back of the site where the outbuildings had been and joined on to his house at No.13, he created a Picture Room and, underneath it, a room known as the Monk's Parlour.

PITZHANGER MANOR

By 1800 Soane felt well enough established in his profession to purchase a country house for weekend and summer entertaining. He settled upon Pitzhanger Manor at Ealing, a village 6 miles to the west of London, and purchased it from the executors of the late Mr Gurnell on 1 August 1800 for £4,500. The brick-built house had been added to piecemeal over many years since the late seventeenth century. Soane immediately set about making extensive alterations, knocking down many of the outbuildings and the older part of the house. One wing had been built by George Dance the Younger, and this Soane retained, because, he said, he admired the interiors and because it was 'the first whose progress and construction I had attended at the commencement of my architectural studies in Mr Dance's office'. The work took two years, and in fact it was not until April 1804 that the house was completely finished (see below).

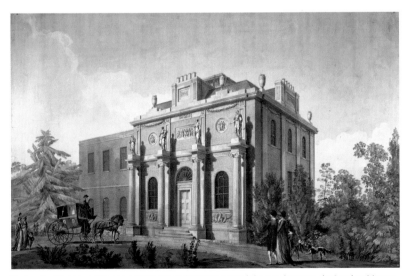

Design for Pitzhanger Manor, c.1800. Mr and Mrs Soane and the two boys are depicted waiting to greet visitors whose coach is drawing up before the house.

With the house came an estate of 28 acres: ornamental gardens had been developed around the house in the early eighteenth century and Soane employed John Haverfield of Kew to redesign these. Under his scheme the house was approached by a new driveway edged with trees, and the lawns at the front and back were edged with curving lines of shrubs. There was also an ornamental bridge, a lake and a plantation. Through the property ran a stream well-stocked with fish. Soane took over the existing kitchen garden to the south of the house and employed a gardener to tend it, and his account books show extensive purchases of vegetable seeds, fruit trees and garden tools. The acreage beyond the ornamental gardens was let to a local farmer for grazing.

Here the Soanes entertained their friends to dinner, to walk in the grounds and to evening parties. On occasion these entertainments were quite grand: in his *Description of Pitzhanger Manor House* published in 1833 Soane describes how the Roman ruins he had constructed in the grounds 'were sources of amusement to the numerous persons visiting this place, particularly on the three days of Ealing Fair, held on the green in front of the Manor-house. On those days it was the custom for our friends to visit us by a general invitation, and it was not unusual to entertain from one to two hundred persons to a *dejeune à la fourchette*: many of whom, after contemplating the ruins and drawings, communicated their sentiments on the subject, which created a constant source of intellectual enjoyment.'

In the same volume Soane describes how he had purchased the house 'to have a residence for myself and my family, and afterwards for my eldest son, who at an early age had made very considerable progress in mathematics and mechanics; he had also shewn a decided passion for the Fine Arts, particularly Architecture, which he wished to pursue as a profession. With these delightful prospects in view, I wished to make Pitzhanger Manor-house as complete as possible for the future residence of the Young Architect.' As the years went by, however, it became clear that to practice as an architect was not John's intention. As Soane expressed it: 'he was inclined to sacrifice the *beaux arts* to the *belles lettres*, as being more congenial to his mind.' Reluctantly therefore in 1809 Soane and his wife decided to sell Pitzhanger, and move all its contents back to London. The advertisement of the sale, which appeared in *The Times* for 21 June 1809, described Pitzhanger as 'A Truly substantial, well-built and singularly elegant modern VILLA, with beautiful pleasure-grounds, in correspondent classic taste; walled kitchen garden, abundantly cropped and planted; and paddock, embellished with stream of water, and luxuriant timber, pleasingly disposed, in the whole about 30 acres'.

CHELSEA HOSPITAL

Meanwhile, in 1807, on his appointment as Clerk of Works to Chelsea Hospital, Soane acquired yet another house, in the shape of an official residence in which he was obliged to spend a certain number of nights a year. The Clerk of Works' House was a small irregularly-shaped building in Paradise Row, adjoining the west end of the hospital stables. On first taking up residence in 1807 he contented himself with a few minor alterations, but in 1815 he transformed it into a symmetrical two-storey villa of distinction and progressiveness. The house was surrounded

The Clerk of Works' house at Chelsea Hospital and the surrounding garden.

The Clerk of Works' house at Chelsea Hospital, showing the vegetable garden.

by flower and vegetable gardens, and was altogether a very pleasant retreat from London. Indeed, after his wife's death Soane spent a considerable amount of his time here, in the company of the friends he and Eliza had made, and talks, in his *Memoirs of the Professional Life of an Architect*, printed in 1835, of now retiring to his 'official residence to enjoy my Chelsea pittance and my ease'.

THE HOUSEHOLD

The Soanes' two sons, John and George, were eight and five respectively when they first moved into No. 12 Lincoln's Inn Fields. Another important member of the family was Fanny, Mrs Soane's pet dog, a Manchester Terrier (see overleaf). They had various other dogs at Pitzhanger Manor, but no others who lived in the house with them all the time. When Fanny died, on Christmas Day 1820, Soane recorded in his diary that she was 'aged ab[out] 16 or 17 years', which probably means that she came to them in about 1803. She went everywhere with her mistress, travelling with her in the carriage when she went on holiday, and when she was writing home to her husband Mrs Soane would sometimes dip her paw in the ink so she could sign the letter too.

Portrait of Fanny, Mrs Soane's lap-dog, by James Ward, 1824. Although this was painted posthumously, it accords closely with an earlier portrait of Fanny which can be seen in the Breakfast Room of No.13 Lincoln's Inn Fields.

Very much a presence in the household too, although they did not live in, were Soane's architectural pupils. They mainly came to him at the age of sixteen and were articled for five or six years. On average each year there were four to six articled pupils in the office and a paid assistant, although from 1830 when the business was very much reduced there were just two. The pupils worked long hours in the office, which was sited in various places at the back of the two houses at various dates: from 8.00 am to 8.00 pm in winter and from 7.00 am to 7.00 pm in summer, Mondays to Saturdays. This regime eased a little in 1810, when the hours were changed to 9.00 am to 8.00 pm. The pupils came and went by the office door on to Whetstone Park, the narrow street running along the back of the houses in Lincoln's Inn Fields, and were strictly forbidden to fraternise with the servants, as this apologetic letter from Charles Malton of 23 September 1800 shows: '. . . permit me, Sir, to assure you, my only reason for going into the Kitchen was to enquire if you were from home as I wanted to step out for half an hour. I confess I was extremely wrong in making use of any subterfuge & hope you will impute it to the surprise of the moment. I beg leave further to assure you I have not nor ever had any intimacy with your Servant – further than common civility I never spoke to the Man.'

To run such a household several servants were necessary. The Soanes employed five: a Butler and a Footman and three females, a Cook and two Housemaids. There was also a Coachman, but he did not live in, Soane not having his own carriage and horses, but hiring them by the year from a local livery stables. In addition, a maidservant and a Cook were employed to work at Pitzhanger, besides the gardener already mentioned, between 1800 and 1810, and from 1807 a maidservant was employed at Soane's official house at Chelsea Hospital.

The servants were paid quarterly, and in addition to their annual wages they also received weekly board wages with which to provide themselves with food and drink. In 1818 (and in fact the rates remained unchanged over many years) the Butler received £10.15.3 quarterly, the Footman £6.6.0, the Cook £3.13.6, the first Housemaid £3.3.0 and the second £2.12.6. Board wages were £0.12.6 weekly

for the men and £0.11.6 for the women. The Coachman also received board wages, although not living in.

The male servants, including the Coachman, wore a livery, including a hat with a band and a greatcoat. Otherwise they would have dressed much like their master in knee breeches, stockings, shirt, waistcoat and coat. The Housemaids would each have worn a plain dress, a neckerchief, a mob cap and an apron, white or check depending on the time of day and the task on which she was engaged. *The Cook's Oracle*, published in 1821 by Dr William Kitchiner, listed the following as being the requirements of a maid servant:

'4 pair of Shoes 2 pair of black worsted Stockings
 2 pair of white cotton ditto 2 Gowns
 6 Aprons – 4 check and 2 white
 6 Caps A Bonnet, A Shawl or Cloak, Pattens, &c.[3]
 Ribbands, Handkerchiefs, Pins, Needles, Threads,
 Thimbles, Scissors, and other working tools, Stays,
 Stay-tape and Buckram &c &c Besides these, she has to make a
 shift and buy petticoats, pockets, and many other articles.'

Over a simple dress the Cook would have worn a large apron, either with a bib, or tied at the waist. She is unlikely to have worn a kerchief, but a cap of some sort was essential.

The female servants slept in the attics at the top of the house, and the two male servants, as was then quite usual, in the Kitchens. The Butler was known by his surname, but the other servants are usually referred to by their Christian names, except for the Cook who was generally known by her title.

Soane seems to have treated his servants well and many of them stayed with the family for several years at a time. Indeed Mrs Barbara Hofland, the authoress and friend of the Soanes, writing to her mother immediately after Mrs Soane's death in November 1815 describes her as 'the best possible mistress to her servants, who idolized her'.

We know the names of nearly all those employed over the years, but there are some about whom, through force of circumstance, we know a little more. The first of these is Ann Collard, who was sadly forced to leave their employ because of serious illness. She had joined the household by 1799, when perhaps the problem first began to show, as she later records in a letter that she had been sent away for three months in that year because of a bad fever. Ten years later on 20 November 1809 there is a dramatic entry in Soane's diary: 'Called down to Anne [sic] in the Kitchen – she was then raving.' Two days later he recorded in his account Journal: 'Went to Mr Warburton's with Mrs S. about Anne, to pay 2 guineas per week.' Warburton and Talbot kept a private mad house in Bethnal Green called the White House. It seems that she got better for a while, but there are entries in Mrs Soane's diary for 18 December 1810 and 12 January 1811 indicating that she had consulted a Mr Vaux about Ann, and a week later her clothes were packed up and taken to St Luke's Hospital. The following day Mrs Soane records in her diary that Ann went back to Bethnal Green. Soane generously continued to support her for the rest of his life, and left her an annuity in his Will. She evidently had periods of remission, as in April 1817 he received a letter from her in Devon where she was staying with her father. This can not

have lasted long, however, as she wrote to her old employer on 24 March 1833 from Guy's Hospital Lunatic Asylum and made reference to the fact that she had been deprived of her liberty for 21 years. The letter, which is written in pencil as she was not allowed pen and ink, is a very lucid one, and leads one to wonder just what the diagnosis of her condition would be today. Her brother, A C Collard, a musician at the opera, collected her allowance periodically from Soane until in 1828 he was forced by ill-health to go and live in Somerset. He appointed their sister, Mary, who lived in Brompton Row and who had always managed the money, in his stead. The family, though, seem to have been doomed to affliction, for in the same year Soane received a letter from Mr Foxhall mentioning that 'the sister of the servant you have for so many years been supporting in her misery is now in confinement for the same malady'.

Another group of whom we know more are the servants in Soane's employ in 1827, when because of a major quarrel between them, which resulted in various accusations and counter-accusations, he was forced to conduct an examination of each, the written record of which has survived. Details of this will be given in Chapter 3.

The last member of the household who must be introduced is Soane's Housekeeper, Mrs Sarah, or Sally, Conduitt. Immediately after his wife's death Sarah Smith, Mrs Soane's friend from Chertsey, came to Lincoln's Inn Fields to run the household. She left, however, in April 1816, after a series of arguments. Her sister Sophia succeeded her, but she too left under a cloud on 15 October. In despair as to what to do Soane turned to his friend Barbara Hofland for advice, even suggesting that he should 'give up Housekeeping altogether & retire abroad'. The solution arrived at was that Mrs Hofland's friend Sally Conduitt, the wife of Edward Conduitt, tenant of one of Soane's properties in Albion Place, Blackfriars, should act as Housekeeper for him. The Conduitts had been introduced to the Soanes by Mrs Hofland a few years previously and had also become friends. Mrs Conduitt did not live in, but came to Lincoln's Inn Fields twice a week or so to oversee the running of the house and do the household accounts. She may well have worn a black dress when on duty; this would make sense of an entry in Soane's diary for 31 July 1816: 'Mrs C. ordered her black dress yesterday eveng., how kind! but she is good indeed!' Soane gave her £50 a year for household expenses, over and above the servants' wages and food and laundry bills, for which she accounted at the end of the year. She does not appear to have been paid for this service, though it is possible that the rent on their house was reduced or waived. The arrangement was a happy one and endured for the rest of Soane's life. Indeed, Mrs Conduitt went on to become the first Inspectress of the Museum in 1837, a post which she continued to hold until her death in 1860. Besides fulfilling the function of Housekeeper, she was very much Soane's friend and companion, dining with him regularly, and often accompanying him on holiday.

3. Pattens were a kind of overshoe worn to raise ordinary shoes out of the mud or wet. They consisted of a wooden sole secured to the foot by a leather loop passing over the instep and mounted on an iron oval ring.

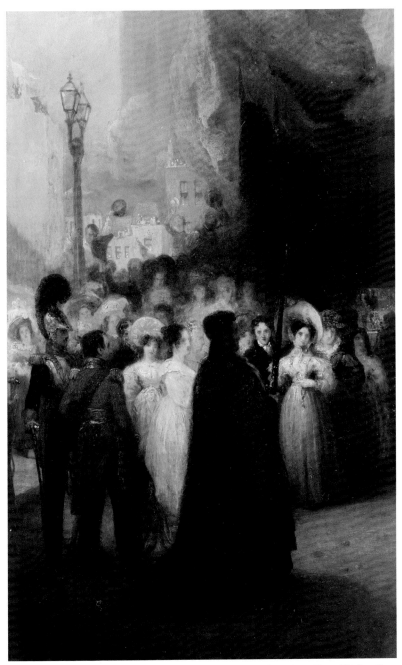

Soane and Mrs Sarah Conduitt, his Housekeeper, at the opening of London Bridge, 1831. Detail from a painting by George Jones. The couple stand facing the Lord Mayor, who holds aloft a sword. Mrs Conduitt is wearing a white bonnet and a yellow dress.

2

SERVICING THE HOUSE

WATER AND DRAINS

SINCE 1741 THE HOUSES in Lincoln's Inn Fields had been supplied with water by the New River Water Company, and Soane paid a quarterly rate for this service to a Collector who came to the house to receive it. The supply was, however, erratic, and liable to drops in pressure, and it is interesting to note that the complaints procedure is outlined on the water rate receipt. For this reason most householders relied on having a capacious storage tank, usually a lead cistern in the front area. Water was then pumped up to a cistern at the top of the house daily using the force pump, or 'engine' as it was termed, under the stairs in the basement, from where it fed the various sinks throughout the house through a network of lead pipes.

It would not have been uncommon for such houses also to have had a well. A well is marked on a plan of the drains made c.1825 in the middle of the Front Kitchen, but is more likely to have been a cistern for storing water. Recent building work has also revealed that the *Pasticcio*, or ornamental column in the Monument Court was built over an old well shaft.

Apart from the main pump there were also several other secondary pumps in the house. There was a pump in the Monk's Yard for kitchen use, and also one in the Scullery, with a sink beneath. On the ground floor, Soane's Dressing Room was supplied with a pump and wash-hand basin (see page 24).

Water was also supplied to a basin and lead-lined sink in the Butler's Pantry. On the second floor there was a wash-hand basin in a recess in Mrs Soane's Morning Room (see page 56), and also one in the Bathroom adjoining Soane's Bedroom,

For Want of Water, Attendance is given at PEEL's Coffee-House, Fleet Street, on Tuesdays and Fridays, from 12 till 1 o'Clock, where Complaints are desired to be sent in Writing.

RECEIVED _____ 1810, of Mr. _Soane_

the Sum of _Thirty_ Shillings

for *Two Quarters* Rent for *Water*, due at *Midsummer*, 1810, to the *New River* Company.

£ *1..10..* _CHinde_ COLLECTOR.

In Case of Fire, or Want of Water, send to

PAVIORS. / TURNCOCKS.

Daniel Maloney, Ormond Yard, Ormond Street / James Givin, 24, Fullwood's Rents, Holborn
Daniel O'Brien, King Street, Drury Lane / Michael Collins, 14, Norwich Court, Fetter Lane
Abraham Jackson, 11, Union Court, Holborn. / David Maloney, 10, Houghton Street, Clare Market
/ John Wilson, Holywell Street
W. Mason, Printer, 3, Spa Fields. / John Galvin, 1, Green Street, Theobald's Road.

ABOVE Receipt for two quarters' water rates from the New River Company.
LEFT View of the Monk's Yard, 1825. Note the water pump in the left foreground.

When this room was created in 1820, the term 'Bathroom' was not in common use, and the room is variously referred to on plans and in bills as the 'Bathing Room' and the 'Dressing Room'. A plumbed-in bath with its own supply of hot water was extremely rare at this date.[4]

built in 1820. This room included a bath fed with hot water from a boiler in the room above, a great rarity at this date. The room communicated with Soane's bedroom (see page 46) through an open doorway, and was separated from it by a partition filled with yellow glass. There is further coloured and stained glass in the window. The wallpaper is the same as that in Soane's bedroom, and the carpet is described in a bill as 'Drab and scarlet Brussels'. The bath is of wrought iron japanned white, framed in deal. It was fed from a copper boiler in the attic above. To the right can be seen a wash-hand stand. Two mahogany settees covered in black horsehair can be seen, and, above one end of the bath three of the six views of temples in Sicily by Luigi Meyer in Soane's collection. The chimneypiece is decorated with an array of blue and white china. Out of sight in this view, standing in a niche in the south wall, is a longcase clock with a walnut and seaweed marquetry case of c.1710 by William Threkeld.

Associated with the creation of this bathroom in 1820 are bills of the same year for 'oil skin for [a] bath pillow' and a 'bath thermometer'. Soane had presumably previously used a hip bath prior to 1820 and a bill for a 'painted hip bath and thermometer' survives from 1813.

When the house was first built in 1813 a bath for the servants is marked clearly on the plans for the basement, off the Butler's Pantry, together with its attendant copper and furnace (see page 34), but this was swept away in about 1825 in Soane's extension of the Museum to form the Basement Ante-Room. The Soanes' first

house in Lincoln's Inn Fields, No.12, had been equipped with a shower bath. No.13 Lincoln's Inn Fields included a number of water-closets. For the servants there were water-closets in the Front Area and the Monk's Yard, described in some plans as 'Servants' Necessaries'. The plumber's bill for the original fitting out of the house also includes a 'lead urine sink' in the Butler's Pantry, but there is no mention of this in the Inventory of the house which was made after Soane's death in 1837. On the ground floor Soane had a water-closet off his Dressing Room. All the water-closets in the house are described as 'Patent Water Closet', a sign that there was much work going on at the time to improve the design of these objects. They would all have functioned in the same basic way, being flushed with water from a tank or cistern operated by a pull-up handle at the side. The apparatus in Soane's Dressing Room, the cistern of which was supplied by a force pump in the Scullery below, is specifically described as being a 'Bramah's Patent Water Closet'. Joseph Bramah had been instrumental, in 1778, in improving the valve at the base of the bowl through which the waste was discharged. Lastly there was a water-closet next to Mrs Soane's Morning Room on the second floor (see page 56).

Although there was a network of sewers in London, they were not quite as we understand them today. They served principally to drain the streets and took only liquid waste away from the houses. London was divided up into areas

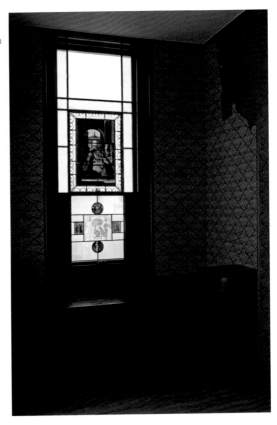

The newly-restored Bathroom, December 2014. Part of the surviving original wallpaper can be seen at the top right. The lid, front and side of the bath are original, as are the stained glass subjects in the window.

The Dressing Room, with the pump and wash-hand basin on the right.

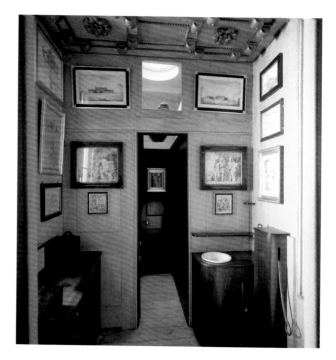

run by different Commissioners of Sewers, and Soane paid a quarterly rate to the Westminster Commission. Solid waste was stored in a cesspool, usually a dome-shaped brick structure covered by a stone slab, in the back yard of the house. This had to be emptied periodically by night-soil men, who, as their name suggests, worked between midnight and 5.00 am, using wooden tubs which they emptied into horse-drawn tanker carts. Unfortunately only one bill survives for this operation for either of the Lincoln's Inn Fields houses: in 1808 a Mrs Sarah Yandall was paid for 'Carting away . . . 36 Tuns of N[igh]t Soil' from No.12.

Receipt for the annual sewer rate paid to the Westminster Commission of Sewers.

HEATING

In both Nos 12 and 13 Lincoln's Inn Fields the residential rooms, including the bedrooms were heated by fireplaces which burnt coal. Large supplies of this fuel were required to keep a house going, as it was the main fuel for both heating and cooking. Coal was delivered by coal heavers in horse-drawn carts and 'shot' into the large coal stores in the Front Area by way of coal holes outside the front of the house at ground level. The decorative metal coal hole covers can still be seen *in situ* today. From the store, coal could be brought into the house as required and placed in coal scuttles in the various rooms. The visitor to the house can still see the panoply of fire-irons, pokers shovels and tongs, in steel or brass standing in each fireplace. This assemblage would also have included a hearth-brush. Another common piece of furniture, of which there are several surviving in the house, was the fire-screen, most usually in the form of an adjustable panel, often decorated with embroidery, on a wooden pole, to protect people's faces from the heat of the fire. Ladies in particular worried about the effect

ABOVE One of the coal hole covers which can still be seen outside the front of No.13 Lincoln's Inn Fields.

Below there – a coalman delivering coal. Note the implement he has used to lever up the coal hole cover.

of the heat on their complexions. When fires were not required in the summer a chimney-board was usually placed in the fireplace, to hide it from view and to catch any soot that might fall. There is green baize chimney-board listed as being in the Study in the 1837 Inventory of the contents of No.13. Chimneys in constant use collected much soot, and the chimney sweep was a regular visitor to the house as recorded in the kitchen account books.

The production of a flame to light the fire, or for other domestic tasks, was not as simple as it is today. Friction matches were not invented until 1831. Until that date a flame was produced using a tinder-box, usually of tinplate, kept by the side of the hearth or the kitchen range to keep the contents absolutely dry. Inside would be kept some flammable material such as linen, which would be ignited by striking a flint against a striker or steel. A match tipped with sulphur would then be lit from this. Mrs Soane records the purchase of just such a tinder-box in her diary for 15 October 1804. As far as possible a flame once lit would be used to light other ones, and spills were much in use – thin slips of wood or folded or twisted paper. Soane kept vases containing these on the chimneypieces in his Library and Dining Room, for the easy lighting of candles or lamps.

Besides coal fires Soane also used metal stoves to heat areas such as the office where his pupils worked. Nevertheless, a former pupil who had joined the office in 1824, Charles James Richardson, could write in 1839: 'I well remember the miserable cold experienced in the office during former periods', although in fact he was writing of a time when the building was heated by an experimental central heating system (see below).

Always keen to keep up with new and developing technology, by 1820 Soane had determined to employ a central heating system to heat No.13 Lincoln's Inn Fields. At first a steam apparatus was installed to heat the offices. This was soon succeeded by a hot-air system in which heat was conveyed from a hot-air stove by means of pipes to heat the offices, the Picture Room, the Museum and the main Staircase. An improved warm-air system was installed by a Mr Feetham in September 1826. In this system the warm air was conveyed by copper flues and admitted to the room by a brass grille in the floor. Examples of these can still be seen today in the floors of the Dressing Room and Study. Two years later Mr Feetham installed an improved version of the system. At the beginning of January 1830 Soane tested this system against another stove he was trying out and recorded the temperatures produced.

The Study. One of the brass grilles for the warm-air central heating system can be seen on the left of the fireplace.

Between 9.10 am when it was lit and 5.00 pm Feetham's stove used 2 bushels of coke and produced temperatures of 52–53° F on the Staircase, 53–54° in the recess from the Breakfast Room and behind the statue of Apollo, 53° at the further end of the Museum and about 55° in the Breakfast Room. That these temperatures were accepted as being 'as they ought to be' tells us much about the difference in comfort-levels and expectations between the early nineteenth century and today, although of course the system was supplemented by fires in the formal rooms.

In 1831 a new hot-water system was installed by H C Price, who claimed that it would keep the rooms at 60° F if it was 30° outside. This clearly did not perform to expectations as it was removed by May 1832 and the last and most efficient of the systems with which Soane experimented installed. This was a high-pressure hot-water system patented in 1831 by A M Perkins. Heat was conveyed by above-ground pipes, of which there were 1,200 feet in all. This was divided into two circulations. The first warmed the Picture Room and the Monk's Parlour and Cell beneath. The second, in C J Richardson's words:[5] 'first warms the office in which the expansion and filling tubes are based; a pipe then traverses the whole length of the Museum, then passes through the breakfast-room under the long skylight, intended to counteract the cooling effect of the glass; then passes through the floor into the lower room, forms a coil of pipe of 100 feet in the staircase and returns to the furnace, passing in its course twice round the lower part of the Museum; a coil from this circulation is likewise placed in a box under the floor of the dressing-room, which by an opening in the floor and the side of the box, admits a current of warm air into the room above.' The furnace which heated the water for this system was situated in the Monk's Yard. So sucessful was this system that it endured right up until 1964, with extensions and refurbishment in 1891 and 1911. C J Richardson sums up well the difference made by a central heating system: 'The comfort and convenience of a moderate, warm, equalizing temperature can scarcely be understood or appreciated, without having been enjoyed. On entering from the open air, it may feel oppressive at a temperature of fifty-five or sixty degrees, but sitting quietly at sedentary occupations, no sensation is felt; we can move about without being aware that the winter snow is outside, and we are not annoyed by being only partially warmed on one side whilst we are chilled on the other'.

LIGHTING

The principal forms of lighting in the main rooms in the house were oil lamps. These burnt spermaceti or sperm-whale oil. Colza oil, derived from oil-seed rape, was increasingly replacing sperm-whale oil at this period, but it is clear from the surviving bills that Soane did not change to it. With the exception of two fixed lamps, one in the Monk's Parlour and one on the balustrade of the main staircase on the second floor, during the day the lamps were stored in a special room in the basement, the lamp closet, where it was the job of the Footman to clean them, to trim the wicks and to refill them with oil. They were then brought upstairs and lit as the daylight failed. That this could be quite early in the day in wintertime is evident from an entry for 31 December 1817 in the memoir of Richard Rush, Envoy Extraordinary and Minister Plenipotentiary from the United States of America from 1817 to 1825:[6] 'The fog was so thick that the shops in Bond Street

RIGHT Bill for sperm-whale oil for lighting oil lamps. The bill also includes lamp cotton, or wicks. The '½ pint Droppings' is described in a note outside of the bill as being 'oil for grates'.
BELOW RIGHT Bill for wax candles, 1829.
BELOW A surviving example of an Argand lamp, which can be seen in Soane's Study at No.13 Lincoln's Inn Fields.

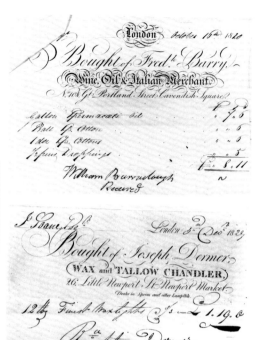

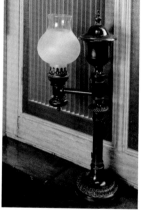

had lights at noon. I could not see people in the street from my windows. I am tempted to ask, how the English became great with so little day-light? It seems not to come fully out until nine in the morning, and immediately after four it is gone.'

A surviving example of an oil lamp (now converted to electricity) can be seen in Soane's Study. This is an Argand lamp, named after a Swiss, Ami Argand, who revolutionised lighting technology in 1784. His lamp consisted of a glass funnel to draw the air more efficiently through a vertical metal tube which was surrounded by a tubular meshed wick; the font or reservoir for oil was at one side, set slightly above the oil-intake which was fed by gravity.[7] We know from a surviving bill that Soane also had a patent sinumbra lamp, so called because the oil vessel was positioned in such a way that the shadow was, if not destroyed, rendered imperceptible, a French ring lamp, and two Rumford Reading lamps, two other variations illustrative of the drive to improve lamp technology at the time.

Before the improvement and spread of oil lamps, candles had been the main source of artificial light, and even after this were used to supplement oil lamps. Their quality varied considerably depending on where in the house they were being used. The servants in the Kitchen had to make do with tallow candles, whereas the finer and more expensive wax candles were employed elsewhere in the house. Candles were also distinguished by whether they were 'dipped' or 'mould'; dipcandles, which were inferior, being made by repeatedly dipping a wick into melted tallow. Candles were burnt in candlesticks, made in a variety of metals, except in the Drawing Rooms where they were burnt in chandeliers hung

from the ceilings. One of the original chandeliers can still be seen in the North Drawing Room (now converted to electricity). Candlesticks could often be quite elaborate, with several branches, and might also, if they were for use when reading or writing, have a metal shade to reflect the light downwards and to protect the eyes from the glare of the flame. On retiring to bed the family would be handed lighted candles in candlesticks to take upstairs with them, and it is interesting that one surviving bill refers specifically to a 'silver chamber-candlestick'. Two other indispensible accoutrements of this form of lighting were the snuffer, a specially adapted pair of scissors with a box on one blade, for periodically trimming the wick of a candle, and the conical-shaped extinguisher for putting it out when no longer needed. Candles, particularly the finer ones, were an expensive item, rendered more so by the candle tax imposed by the Government until 1831. Like soap, sugar, tea and coffee, they were kept under lock and key by the mistress of the house or the housekeeper.

The outside of the house was lit by an oil lamp over the front door, which supplemented the oil lamps in the street provided by the Lincoln's Inn Fields Trustees. Soane, in common with some of the other householders, paid the

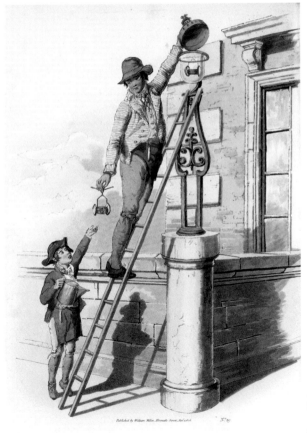

A lamplighter, illustrated in Pyne's *The Costume of Great Britain*, 1808.

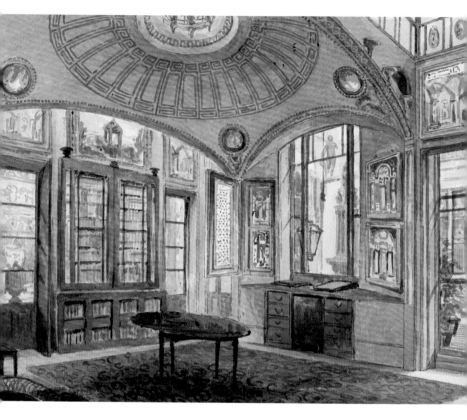

lamplighter employed by the Trustees (or rather the contractor's man) to light this outside lamp. For many years this was a man called John Patrick. In 1819 the Trustees of Lincoln's Inn Fields paid the Gas Light and Coke Company for erecting four large gas lamps with square lanterns on the north and south sides of the square, and in 1824 all the remaining oil lamps in the square were replaced by gas. Soane incidentally took the opportunity of saving four of the stone obelisks on which the oil lamps had been mounted, and these can be seen today in the Monk's Yard and West Corridor. Four years later he had a gas lamp installed in the Monk's Yard, paying a quarterly rent for gas to the Gas Light and Coke Company. This seems to have been a short-lived experiment, because by 1830 that lamp had been taken down and another installed in the Monument Court, attached to the window sill of the north window of the Courtyard. Gas was still not particularly reliable at this date, and the bills show that he had to have a man in at frequent intervals to clear water from the gas pipes and to attend to the burner. Soane never introduced gas into the interior of the house. Although there are instances of it being used domestically at this date, it was still regarded with some suspicion, not least because of its smell. The light it produced, whilst certainly brighter than that produced by oil lamps, was also, with its greenish glow, felt to be unflattering to ladies' complexions.

LEFT View of the Breakfast Room in No.13, 1830. The gas lamp in the Monument Court is visible through the window.
RIGHT Reconstruction of the Front and Back Kitchens and associated offices as they were in 1837, drawn by Peter Brears.

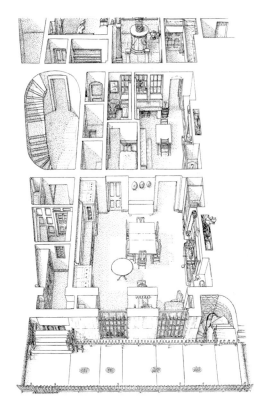

THE KITCHEN

The kitchen consisted of a Front and Back Kitchen with a Scullery behind, and various associated offices (see pages 34–5). Cooking was done on coal-burning ranges in both kitchens. These had built-in ovens and hot plates. Both ranges also had two roasting spits powered by a smoke jack, a mechanism powered by the draught up the chimney from the fire. An extra hotplate, set in brick, underneath which there would have been a fire, stood next to the range. The range in the Back Kitchen, which still survives (see page 38), included a boiler for heating water, which could be drawn off by means of a tap. There was also a separate Copper for boiling water in the Front Kitchen, and a Copper specifically for laundry in the Back Kitchen. Both of these were set in brickwork, and would have had a fire underneath.

4. Verbal communication from David Eveleigh to Helen Dorey, Deputy Director, 2014.
5. C J Richardson *A Popular Treatise on the Warming and Ventilating of Buildings: showing the Advantage of the Improved System of Hot Water Circulation*, 2nd ed. 1839.
6. Richard Rush *A Residence at the Court of London*, Century, 1987.
7. I am indebted to Peter Thornton *Authentic Decor: The Domestic Interior 1620–1920*, Weidenfeld and Nicolson, 1984, for this explanation.

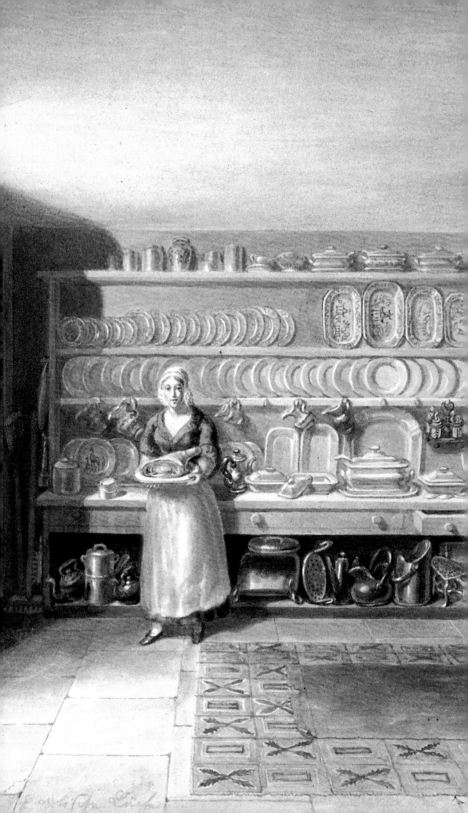

3

THE SERVANTS' DAILY ROUND

ACCOMMODATION

LIFE FOR SOANE'S SERVANTS centered around the basement of the house: the Front and Back Kitchens and associated offices (see overleaf). Here they would spend their time when not engaged in duties elsewhere in the house or having rare time off. Indeed, as was usual at the period, the male servants slept in the basement; the Butler in his pantry, and the Footman in the Front Kitchen, probably in a bed boxed in by doors. The sleeping accommodation for the female servants was on the third floor of the house, initially in garrets which were later extended to a whole floor. The servants' necessary or water-closet was, as we have seen, in the Front Area, with another one in the Monk's Yard. The plan of No.13 Lincoln's Inn Fields as first built shows a servants' bath in the basement, although this was later sacrificed to the extension of the Museum in the shape of the Basement Ante-Room.

THE HOUSEMAIDS

The day began early for the servants, with much cleaning and preparation to be done before the family arose. Much of this fell to the two Housemaids. The kitchen fires had to be lit, using wood chopped by the Footman and kept in a large log box, and water boiled in the Copper so that hot water could be taken to the bedrooms for washing. The shutters had to be opened and the grates cleaned before the fires could be prepared and lit. The carpets had to be cleaned and the rooms dusted, the beds aired and remade and the bedrooms tidied. One of the Housemaids would also have assisted Mrs Soane to dress and make her toilet (see Chapter 4).

There was not, of course, the range of proprietary liquids and creams available for cleaning that there are today. Bare wooden floor boards (and indeed the tables and dressers in the kitchens) were scoured with soap and sand and hot water. Two sorts of soap were regularly purchased – mottled and yellow soap. They were bought by the hundredweight, and, as valuable items, were kept under lock and key by the mistress of the house. The grates and fire-irons were rubbed first

Detail of the kitchen in George Scharf's house, No.14 Francis Street, c.1843. Note the dresser, which is almost identical to that surviving at No.13 Lincoln's Inn Fields (see page 37). Pots and pans and other kitchen equipment are stored on the bottom, or 'pot-board' whilst the shelves above are for crockery. In Soane's kitchen earthenware crockery was used, the china used by the family being stored in a separate china closet.

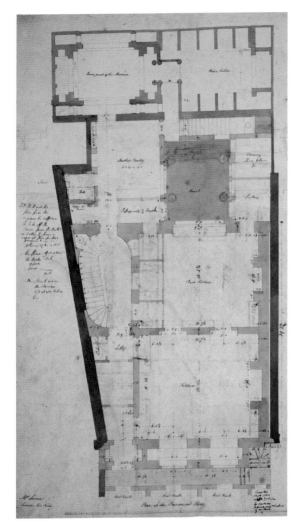

LEFT Proposed plan of the basement of No.13 Lincoln's Inn Fields, 1812.

OPPOSITE
TOP Plan of the basement of No.13 Lincoln's Inn Fields drawn shortly after Soane's death in 1837.
BOTTOM LEFT Bill for washing and cleaning materials – soft soap, pearl ash and scouring paper. It is interesting to note that a particular brand of black lead known as 'Servant's Friend' is specified.
BOTTOM RIGHT Bill for a variety of household brushes. Some brushes would be made of pig's bristles, hence the illustration in the bill-head.

with oil and then with emery paper or brick-dust and finally with scouring paper. The backs and sides of the fireplaces were brushed over with black-lead and then rubbed with a special brush. The marble hearth-stones were washed with flannel dipped in soap and hot water and dried with a linen cloth. Dusting was done with dusters made of a check material, and carpet and other cleaning with what seems to us, in our mechanised age, an astonishing variety of specialist brushes for different tasks. The brushes for the household were purchased from Benjamin Bishop of 208 High Holborn, and bills survive for brooms, scrubbing brushes, carpet brooms, long hair brooms, dusting brushes, stove brushes, blacklead brushes and even bannister brushes.

The cleaning of the mahogany furniture in the ground- and first-floor rooms and the cleaning of looking-glasses and pictures was the preserve of the Footman.

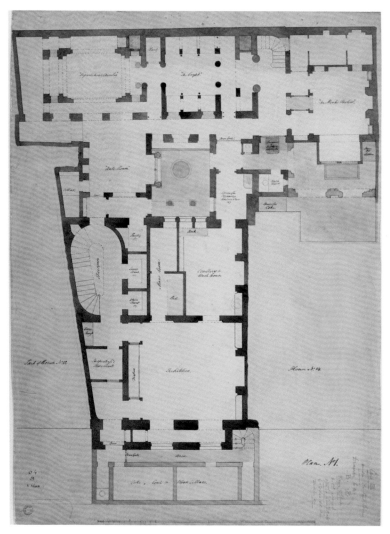

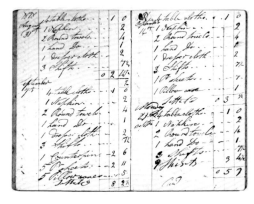

A page from the Washing Book for 1817–21, showing the household linen sent weekly to the washerwoman. The charges per item were added up weekly, and the book signed periodically by the washerwoman to show that her bill had been settled.

The Housemaids would also have been responsible for such washing of clothes and household linen as was done on the premises. Some at least was sent out to a washerwoman, a record being kept in the Washing Book. In this, weekly entries were made on Mondays of the items taken, mainly household linen such as towels, bed linen and napkins, and the amount charged by item, with weekly totals. The Washing Book for 1817–21 is inscribed on the back inside cover '1821 17th February settled all to this day Ester Cherry.' No Washing Books survive from Mrs Soane's lifetime but there are periodic entries in her diary such as that for 26 Dec 1804: 'Settled all with ye Washerwoman.' In Soane's plan for the basement of No.13 of 1812 'Washing Tubs' are marked as being in the Front Kitchen, but in the event the Washing Copper was positioned in the Back Kitchen, which is referred to on one plan of 1837 as the 'Scullery and Wash House'. The Copper was fixed in brickwork next to the Range, and would have been filled with water, heated by a fire below. In this the washing would be boiled, having first perhaps been soaked in the round wooden stave-built washing tub. The 1837 Inventory also includes a 'washing stool'. Soft-soap was used for washing, eked out by pearl-ash to make it go further. Blue, a compound of indigo with starch or whiting, was used in both stone and powder form to bring out the whiteness in materials, and starch was used after washing on those garments requiring it. Some heavy items were sent out to be mangled after washing; the Cook's Book for 1819–20 records a payment for 'Mangling bed furniture and sofa cover'. Mangling was not the wringing operation it later became, but a form of pressing under a heavy roller. Washing Day was a physically demanding day, and it is interesting to note that there are several entries in the Cook's Book for 'Washing Beer' or 'Beer for Washing Day'. Ironing was done using a heavy ironing board, also kept in the Back Kitchen, placed on a table. The flat irons for ironing the clothes would have been heated in the fire of the Kitchen Range. There was also a wooden press for napkins and other linen.

Repairs to household linen and replacement of such things as net curtains also had to be done by the Housemaids, under the supervision of Mrs Soane, and later Mrs Conduitt. As one instance of this, it is clear from Mrs Conduitt's household accounts that the small half curtains at the bottom of the windows in the Library were replaced about every two years; muslin being purchased for the purpose and then dyed yellow with turmeric and fixed with alum.

Later in the afternoon the Housemaids would help to carry up the dinner, and subsequently would prepare the bedrooms for sleeping, warming the beds with a warming-pan filled with hot coals if the season demanded.

THE COOK

The Cook's day began with the preparation of breakfast. After breakfast she would have received her instructions for the day from Mrs Soane. The Cook was responsible for buying provisions and examining, checking and paying the tradesmen's bills, being repaid weekly by her mistress. She kept a running account of this expenditure in her 'Cook's Book'. Many of the provisions would have been delivered by the tradesmen, who used the Area steps – a small flight of steps leading from the street straight down to the Kitchen door, which can still be seen today. Provisions had to be purchased daily as there was as yet no method of keeping ice in a London town-house, and meat had to be stored in cupboards with marble shelves and mesh doors. These were situated in a cool passage outside the

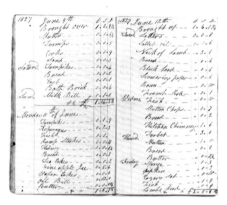

LEFT A page from the Cook's Book for 1827. Daily expenditure on food and household supplies is noted by the Cook. The book was settled up weekly by Soane's Housekeeper, Mrs Sarah Conduitt, whose initials we see half-way down the left-hand page.

BELOW The dresser in the Front Kitchen of No.13 Lincoln's Inn Fields. An idea of how it would have looked when in use can be gleaned from page 32. A selection of pestles and mortars of various sizes has been included in the picture.

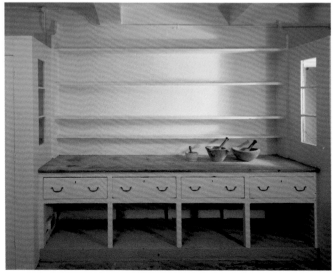

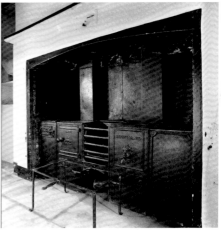

Original food cupboards in the passage leading out to the Front Area (see drawing on page 31, bottom left).

The surviving kitchen range in the Back Kitchen of No.13 Lincoln's Inn Fields. Installed when Soane built the house in 1812–13, it is a rare survival of a range of this date, replacements usually having been made over the succeeding years. It was a very sophisticated model for its period, and represented the latest in technology. In front of it stands the frame for the dripping pan, used when meat was being roasted.

main back door of the house. To improve the air circulation the iron gate leading from the passage into the Front Area was not a solid barrier, but covered with wire mesh. Mrs Soane went to market from time to time, as can be seen from entries in her diary, for instance to nearby Clare Market. She also records going to settle her accounts with various tradesmen. The rest of the Cook's day would of course have been occupied with the preparation of food.

The Butler

Meanwhile the Butler[8] would be busy answering the front door, taking in messages and receiving the cards of callers. George Wightwick[9] describes how when he visited the house in 1826 'I was told by the direction on the plate to "knock and ring"; but a romantic humility subdued me, and I rang only. A man-servant admitted me and took my card. In a few minutes he beckoned me forward, and I entered the breakfast room, where the veteran was seated.' The front door bell rang outside the Kitchen door. The bells in the various rooms of the house which could be used to summon the servants rang in the Front Kitchen and were connected by a network of wires, portions of which survive, particularly on the second floor.

The wine cellar was also the Butler's preserve and he would have to supervise any deliveries of wine, and the related bottling processes. The wine cellar was at the back of the basement (see page 34), and consisted of brick divisions and stone shelves. One of the plans of the house shows an opening near the office door on to Whetstone Park down which pipes of wine could be let into the cellar.

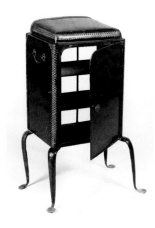

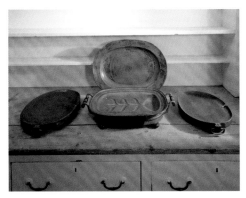

LEFT The surviving plate-warmer. There are shelves inside for the plates, and the back is open, so that it could be placed in front of a fire. The plate-warmer, which is in unusually good condition, is japanned, a term used to decribe a kind of hard varnish, and decorated with a trellis-work pattern.

RIGHT Metal dishes used for serving food, which had a reservoir underneath for hot water to keep food warm.

When Soane created the Crypt in c.1835–6, wine storage was relocated to a small room off the south-west corner off the Basement Ante-Room (see page 35), with wooden shelves and 'wine binns' of York paving. The Butler was responsible for bringing up the wine from the cellar as required and decanting it etc. as necessary. He had the care of all the glass and plate, sleeping in his pantry to safeguard it. Also in his pantry was a lead-lined sink in which the glasses could be washed without danger of breakage. He would have worn a large apron whilst engaged in such tasks. Glass was cleaned with hot water and a soap or scouring agent such as Fuller's earth beaten into a fine powder. The glasses would be placed upside down on a cloth to drain and then polished with a 'glass cloth'. Plate was first washed in boiling water to free it of grease, a special plate-brush being used for any crevices. It was then rubbed over with a powder such as whiting or hartshorn (an aqueous solution of ammonia) applied wet and rubbed until dry with a plate leather, another plate leather being used to give a final polish. Every Butler would have had his special mixture which he thought gave the best results, and there are numerous variations in the published books of advice of the period. For cleaning forks special fork brushes were available for getting between the tines. Knives were subject to a different process and cleaning them was the province of the Footman. The china was washed up in the Back Kitchen by the Cook or one of the Housemaids, where there was a sink and a wooden plate rack for draining.

The laying of the table in the Dining Room and the serving of meals was the job of the Butler, the food being brought up from the Kitchen by the Footman and Housemaids. In this they were assisted by a dumb-waiter, or lift operated by ropes, which went from the Back Kitchen to the Dining Room. It can no longer be seen today, as by 1822 Soane had it converted to form an extra space for books. After that date meals had to be carried up and down stairs on trays. Food would be kept warm in its passage upstairs under large domed metal dish covers. The metal dishes on which the meat or other food sat had a reservoir underneath for

hot water. It was also the Butler's job to take the tea things to the Drawing Room in the evening.

Finally, last thing at night it was the Butler's job to lock the front door and make sure everything was secure for the night before retiring. We know from one bill for 1808 that Soane kept a gun – a blunderbuss, but whether this was for extra security in the house at night or to be used when travelling in his carriage is not clear.

THE FOOTMAN

The Footman's first task of the day was to pump water up to the cistern at the top of the house using the force pump under the stairs. Another of his responsibilities was the cleaning of all the boots and shoes, a task carried out in a special room for the purpose in the basement. He also probably acted as Soane's valet, and would have brushed and laid out his clothes, laid out his shaving apparatus and various toilet articles and attended him while he dressed (see Chapter 4). This role would have been fulfilled by the Butler when he accompanied him on his travels, as Joseph Beynon did for many years.

The Footman was also responsible for the cleaning of the knives, which had a special room dedicated to this function in the basement. This was a task which required much application, and for which, as for all his dirtier work, he wore a leather apron. The blades of the knives were rubbed with bath-brick, a block of powdered limestone, or against a knife-board spread with a paste including emery powder. A deal knife-board and stand with an iron leg is listed in the 1837 Inventory, and both bath-brick and emery powder occur in the kitchen bills.

It was also the job of the Footman to look after the oil lamps, placing them in the rooms where they were required and lighting them when it got dark, and collecting them up and taking them down to the lamp closet the following day. Here he would clean them, trim their wicks and fill them with oil ready for use again in the evening.

When not engaged in these cleaning jobs the Footman had to be available to run errands for the master and mistress of the house, and to attend them when they went out in the carriage.

THE COACHMAN

As has already been explained, Soane did not have his own carriage but hired one, together with the requisite harness, for one or two years at a time from a local firm. For many years he hired a 'Patent Axletus' from a firm called W Harman & Son in John Street, off Oxford Street. He also hired a pair of horses from a local stable, where he would pay for their keep. From 1827, for instance, he was paying William and George Cable of the Bull and Gate Inn, High Holborn, for this service. His coachman, who was probably supplied by the firm from whom he hired the horses had his clothes and also stable utensils included in his wages. He would bring the carriage to the house whenever Soane or his wife wished to go out in it. On occasion they would use their carriage to travel outside London, but quite often when he went on business journeys Soane would use the extensive network of public coaches plying on various routes from different London inns.

Leisure Time

The servants, in common with all those of their class at the time, had little leisure. They were, however, accorded occasional treats by their employers. On 25 July 1804 Mrs Soane recorded in her diary: 'Mr Soane left town for Cricket [home of Lord Bridport, one of his clients]. Servants went to Vauxhall [the pleasure gardens south of the river].' Similarly on 15 January 1805, as on various other occasions, she noted: '. . . servants had a dance'. On 29 March 1806 she 'Sent Ann and Nichols [the Butler] to the play.' Nor were such treats confined to their mistress: Soane records on 6 January 1811, the feast of Twelfth Night: 'Treated the servants with cake etc. 12/-.'

Diversion of a different sort was provided for the male servants from 1798 when during the Napoleonic Wars, to counter the perceived threat of an invasion, Volunteer forces of militia were raised and employers were required to enlist their servants. Weekly training was engaged in and for this they wore a uniform. Soane recorded in his Account Journal for 24 April 1806: 'Gave Nicholls for a new Volunteer Uniform £5.0.0.'

Arguments Among the Servants, 1827

The dispute between Soane's servants of 1827, already alluded to in Chapter 1, is useful in putting some flesh on the bare bones of this account of the servants' daily round.

The Butler at the time was Joseph Beynon, who had begun his service in the household as a Footman in about 1811, and been promoted in 1817 or 1818. He acted very much as Soane's right-hand man, often travelling with him when he left London. He was clearly quite well educated, and it was he who at other times kept a record of the correspondence received while Soane was away, and kept the kitchen accounts after Mrs Soane's death. Joshua Smith, the Footman, who was nineteen years old, had joined the household on 18 February 1826. The Cook was Frances Evans, who had been in the household since at least 1818. She was clearly not able to write with ease as she nearly always signed the receipt for her quarterly wages with a mark instead of her name. One of the Housemaids, who had come to Lincoln's Inn Fields in October 1818, was called Mary Turner,

Signatures of Soane's servants for one quarter's wages, 2 March 1827. Both Frances Evans, the Cook, and Catherine Warlow, (Catherine Hazelwood), the Housemaid, have signed with a mark, though we know that Catherine at least could write, see page 43.

41

and the other Catherine Hazelwood. Born Catherine Warlow, she was a native of Wales, and had joined the household in September 1825. On first leaving her native country she had lived with her Mother's sister at 13 Paradise Row in Woolwich for two years before going to work for a Mrs Bicknell at Greenwich, leaving her employ after a warning about oversleeping. Immediately before coming to work for Soane she had worked for two months for a Miss South and her brother, an apothecary, in the Borough. She had then spent a week in the country with her aunt in Uphill, Somerset, before coming back to work for a month or so for a widow, Mrs Daniel, of 7 Keppel Street, Borough. Catherine was married to a Charles Hazelwood, a waiter at Tom's Coffee House in Cornhill, where he lived in.[10] He would call in to the Kitchen at Lincoln's Inn Fields for a cup of tea or to eat with her every so often, and when they had occasional time off they would go to his father's house in Welbeck Street. In October 1826 he had taken a furnished room in a house belonging to a Mrs Gardner in a Court near Basing Lane, St Paul's, so that they might have a place to meet alone.

The allegations and counter-allegations of May 1827 mainly concerned drunkeness. Trouble seems to have begun when Joshua said to Beynon that Catherine was a drunkard. On the night she had been to the Old Bailey to give evidence in the trial of a thief caught stealing carpenter's tools from No.14 Lincoln's Inn Fields, (then being rebuilt), she had, he said, been so drunk that she had gone to bed, and had had to be called up by Mary Turner, the other Housemaid, to warm her master's bed. He had seen her with a glass bottle which might contain gin. She generally drank ale or porter at dinner, he continued, and occasionally wine or spirits diluted with water at dinner or supper.

These accusations were strongly denied by Catherine and by her husband. On the night of the trial she had gone into Gibsons, the public house on the corner of Kingsgate Street, to get change and had met Beynon there, who had persuaded her, somewhat against her will, to have a small glass of brandy and cloves. On returning home her husband had come and supped with her on boiled beef which she had got from the Cookshop in Holborn. She had drunk nothing after he left at about 9.30 pm. She had, she continued, never been drunk. She occasionally drank gin and water at meals and sometimes ale. Half a pint of gin lasted between four days and a week. Sometimes she gave gin to her fellow servants, and sometimes they to her.

She countered with accusations of Joshua's laziness and drunkenness. All the winter, she was, she says, obliged to do Joshua's job for him of chopping wood for lighting the fire. When Soane was absent in Bath in October [1826], Mrs John Soane's [widow of John Soane junior] servant came to Lincoln's Inn Fields and Joshua went out from about 12.00 to about 5.00 or 6.00 pm. He was so tipsy when he returned he could hardly stand. He sat down in the Kitchen for about five minutes and then got up and went into the Monk's Yard being sick all the way. He remained there some time and was then brought into the Back Kitchen by the Cook, who asked Catherine to help her put him to bed as he would catch his death as he was leaning over the sink. Catherine carried him into the Front Kitchen and took off his coat, waistcoat and stockings and put him to bed. She had not, she continued, seen him in such a state since, but she had seen him the worse for liquor at different times. He had been and continued to be very insulting and impudent to her. She did not mention the incident to Soane as she thought it 'would only create words'.

There was clearly no love lost between Catherine and Beynon, and she describes several incidents where he got her to do various household tasks, such as cleaning the stair-carpets, by threatening her untruthfully with the imminent arrival of Soane from his Chelsea house. Beynon clearly used Soane's absences to throw his weight around. Catherine Hazelwood also described a number of occasions when during Soane's absence Beynon was out for long periods, sometimes coming back intoxicated.

The conclusion of this sorry episode is revealed in Soane's diary entry for 21 May 1827: 'Gave Beynon, Joshua and Mary warning to quit on Wednesday night or Thursday morning.' In the case of Beynon this must have been quite a wrench for Soane, as he had been in his service for sixteen years and he had come to rely on him quite considerably. Beynon evidently went into business of some kind, for in January 1833 he wrote to Soane from an address in Grafton Street East, Fitzroy Square, asking for a loan of £100 on the lease of his premises, his business being in difficulties; the request was tersely refused.

The year 1827 continued as a turbulent one in the household, several servants coming and going in quick succession. In October Catherine Hazelwood wrote to Soane: 'Sir, I feel it my duty to inform you of Steward['s] [Thomas Stuart, one of several replacement Butlers] Conduct during your absence he left your house to day a little after 3 Clock and hee is not returned. i lock up the Doors preciseley at a 11 Clock and i watch the gate till 12 Clock and i wish you to now it before you came home. sir i dont wish any one to now that I have wrote to you.' Another manservant, Charles Reay, who had come to Soane from his friend and client Purney Sillitoe, had to be dismissed on 24 December after barely a month. As Soane said in his letter of reference: '. . . I believe him to be sober & honest – his situation with me was one of trust & having been informed of his being frequently absent when I was at Chelsea he was dismissed my service.'

It would be wrong, however, to leave the reader with such a bleak picture of Soane's household. Things settled down again the following year. Indeed in a rare personal comment Soane records in his diary on 15 June 1828: 'At Chelsea, much pleased with my new lad – everything altho' the first time set right for Dressing.' For the last few years of his life there was little change in the household, and several of his servants were rewarded with annuities in his Will for long service, over and above the £10 received by all the servants.

8. The reader is referred to the *Diary of William Tayler, Footman, 1837*, ed. Dorothy Wise with notes by Ann Cox-Johnson, St Marylebone Society, 1987 for a fuller and very entertaining account of a manservant's duties. Though William Tayler is styled 'Footman' rather than 'Butler', his duties and the pattern of his day correspond very closely with that of Soane's Butler.

9. George Wightwick, Architect (1802–72) acted as amanuensis and assistant to Soane for a period in 1826. His autobiography, from which this quote comes, was published serially as 'The Life of an Architect' in *Bentley's Miscellany* xxxi-xxxv, 1852–4; xlii-xliii, 1857–8. Substantial passages relating to his time with Soane are quoted in A T Bolton *The Portrait of Sir John Soane R.A.*, Soane Museum, 1927.

10. William Tayler was in a similar position, see note 8 above.

4

FAMILY LIFE IN THE HOUSE

MORNING TOILET

BOTH MR & MRS SOANE would have been awakened in their bedrooms on the second floor by the Footman and one of the Housemaids respectively bringing them a jug of hot water for washing. The servants would then have stayed to help them wash and dress. The water was poured into a basin in the dressing or wash-hand stand, in front of which Soane would sit in his night-shirt and dressing-gown, having taken off the nightcap in which he slept.

Eliza and John had separate bedrooms, as was then the custom, and Eliza slept in the front room on the second floor, her bedroom communicating with her Morning Room (see page 56). Some years after her death, in 1834–35, her bedroom was turned into Soane's Model Room.

It is clear from surviving bills that the wallpaper in Soane's bedroom (see overleaf), as in the bathroom (see page 22) and the front bedroom, had remained the same (with repairs and replacement) since the couple had moved into the house in 1813, and so it must have been chosen by John and Eliza together. It is described as 'Duff yellow on Maroon', and a sample survives in the Order Book for the firm that supplied it – Cowtan & Son – in the Victoria and Albert Museum. The carpet is also the same as that in the adjoining bathroom (see page 22).

The mahogany four-post bedstead is dressed in chintz cotton bed furniture with the valence lined with green calico bound with white lace. In 1830 when the room was redecorated, the bed furniture was changed for 'drab fawn super Moreen [morine] bound with silk ornamental lace, with full drapery valens [valence] fringed with twine fringe'. The arrangement of the furniture was altered at the same time, and the bed moved to the west side of the room.

Between the two bedrooms ran a small east-west passage known as the 'book passage', which still in the 1830s housed a number of books which had belonged to Eliza.

In the lobby at the west end of Soane's bedroom, the windows of which are filled with stained glass, there was, at the date this view was made, a watercloset. (see overleaf). The object visible to the right, beyond the door, may be a sponge on a stick (toilet paper not having been invented until the second half of the nineteenth century).[11]

Portrait of Soane by William Owen, 1804.

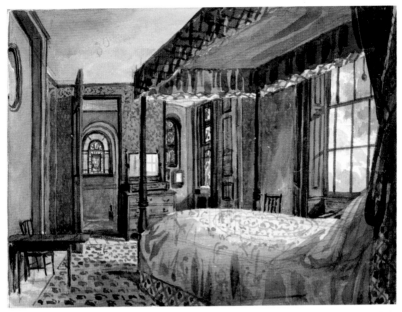

View of Soane's bedroom, the back room on the second floor of No.13 Lincoln's Inn Fields, in 1825.

For personal as opposed to household use, squares of toilet soap were purchased, often violet-scented, although there is one reference to the more masculine sounding 'Military Cake'. Towels were of linen, rather than the cotton material in common use today.

To shave Soane used a cut-throat razor. These were purchased half a dozen or so at a time, and regularly ground and set by his hairdresser. They may well have been engraved with his crest, as there is a reference in one bill to 'engraving razors'. The razor would first have been sharpened on a strop, or strip of leather, and shaving soap applied with a shaving brush (one bill refers to 'a shaving brush filled with Badger's hair'). Sometimes the shaving soap was perfumed: one bill survives for otto (or attar) of rose shaving cake.

Hair was cut periodically by the hairdresser, and dressed daily with pomatum (or pomade). This came in two forms, soft in a pot, and hard in a stick. Sometimes a perfume is specified, for example '2 pots pomatum (No.4 Jasmine)'. The pomatum would enable hair powder to stick to the hair if it were being used (see below). Perfumed oil could also be applied to the hair, for example oil of roses. Hair brushes were supplied by the same brush manufacturer who supplied all the cleaning brushes for the household, Benjamin Bishop of 208 High Holborn. He also supplied them with nail brushes. Combs were supplied by the hairdresser.

The donning of his wig would have been another part of Soane's morning toilet. Many bills survive for patent crop wigs or headresses over the years, as also for repairing them. He probably had several at any one time, and when not in use they were kept on wig-blocks. It was fashionable to powder one's wig, for which orris-root powder, made from the roots of irises, was used. This had a smell like that of violets, and was purchased 12 or 14 pounds at a time from the hair-

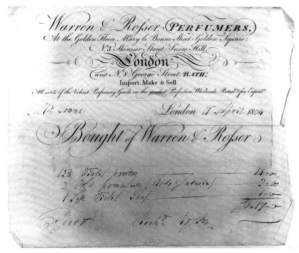

LEFT Bill for hair powder, jasmine-scented pomatum and soap, 1804. **MIDDLE** Bill for nail brushes, 1828. **BOTTOM** Bill for two head dresses or wigs, a fleck brush and oil of roses, 1833. It is interesting to note that extra light wigs are specified; presumably the eighty-year-old Soane was finding anything more too cumbersome to wear.

dresser. To make sure that no traces were left on one's clothes after dressing one purchased a 'fleck brush'. Hair powder was in fact a useful source of income for the government, as there was a tax on it from 1786 to 1869. In Soane's Account Book for 4 April 1801 we find the entry: 'Pd. 1 yrs hair powder tax £1.1.0.' By the end of the eighteenth century wigs were going out of fashion. The fifty-one-year-old Soane is wearing one in the portrait by Owen of 1804 (see page 44), but his sons, portrayed in the same year, are sporting their natural hair (see page 82). It is not always possible to tell from portraits whether a wig is being worn, or whether the natural hair has been powdered. By the end of his life, as we see from the portrait painted of him in 1828 by Sir Thomas Lawrence, which hangs in the Dining Room of No.13 Lincoln's Inn Fields (see page 60), Soane was affecting a dark brown wig to look like natural hair.

Teeth were cleaned using a tooth-brush, also supplied by the hairdresser, and tooth-powder. Mrs Soane recorded in her diary for 28 May 1805: 'Bought . . . tooth powder 2/9.' She at least also used tooth picks, as is evidenced by an entry in Soane's Account Journal for 23 April 1794: 'Paid Mr Green for a Tooth Pick Case [for Mrs Soane] £4.14.6. Pickers £0.4.0.' Visits were also paid to the dentist; on 20 July 1804 Mrs Soane recorded in her diary: 'John went to Scormans to have his teeth cleaned cost 10/6.' Poor Soane had trouble with his teeth in later life. He had a partial set of dentures fitted, and seems to have gone from dentist to dentist trying to get them right. In 1829 he was using Thomas Howard of Fleet Street, though evidently with no satisfaction as he has scrawled 'Quack' on the outside of one of his bills. A correspondence ensued in which the dentist tried to persuade Soane to persevere: '[he] cannot still think the Case quite Hopeless – Should Mr Soane at any time feel disposed to persevere farther he will be happy to attach the Upper Row which he has had ready some time'. On Soane's instructions he sent him the 'Upper Row', commenting that '[I] much regret that you did not persevere a little more as I am confident you might have overcome every difficulty'.

There is, sadly, less surviving evidence relating to Mrs Soane's toilet. There are references in the hairdresser's bills, however, to a 'Swan down puff' and to 'Hair ribbond' and a 'Roseatte', which one presumes were for her. In one tantalisingly brief entry in her diary for 7 May 1807 she records: 'Bespoke face cream etc. etc.' Her hair remained a wonderful rich reddish-brown colour right up until the end of her life, as we can see from a lock which was cut from her head just after her death, and which is preserved in the Museum.

CLOTHES

Soane's undergarments consisted of a pair of linen or flannel drawers, and, at least in winter, an under-waistcoat of flannel. On his legs he wore fine woollen hose, held in place just below the knee with garters. Over this he wore breeches, usually of black kersey, fastened at the knee, and a white shirt and neckcloth. The cuffs of the shirt were held together with sleeve-buttons (or cuff-links as we would call them). These were, at least on occasion, of gold, as Soane refers in his account Journal for 23 December 1797 to paying Robert Makepeace, a goldsmith and jeweller, twelve shillings for mending a pair. Over the shirt went a waistcoat and a coat, usually of fine black cloth. These garments, with the exception of the shirt and neckcloth, were made for Soane by his tailor, one of several he patronised

Bill for shoe repairs, 1818.

Bill for a hat, 1817.

over the years. The two boys were also kitted out by the same tailor once they had graduated from the frocks that they would have worn until the age of four or five. Mrs Soane refers in her diary for 30 July 1806 to paying for seven shirts for her husband, but there is no record of whom she got to make them. After her death, Mrs Conduitt patronised the Magdalen Hospital for the Reception of Penitent Prostitutes for this purpose, paying them in 1817 for 'Making 24 shirts, 14 neck-clothes, 8 pocket handkerchieves and marking buttons.' On another occasion in 1833 she had recourse to the Royal Freemasons' School, the bill for making sixteen shirts being marked 'work done by the children'.

Numerous bills survive for Soane's shoes, and for shoe repairs. It must be remembered that he did a great deal of walking, thinking nothing of walking between Lincoln's Inn Fields and his house at Chelsea, and the leather soles must have worn through quite quickly. For many years he patronised George Hoby, Boot and Shoe Maker in St James's. Shoes, and less often boots, were purchased, and there are also references to galoshes and to 'Spanish' or 'Morocco' slippers for indoor use. In 1835 Soane ordered a pair of shoes in kidskin, lined with silk.

For outdoor wear he would have had a 'great coat' made by his tailor, and he would have sported a hat. Hats are another item for which numerous bills survive, showing that they were purchased quite frequently. A bill of 1810 includes an 'Extra superfine Corbo Beaver' hat. Soane would also have worn or carried gloves, and records in his Account Journal for 5 February 1790 that he paid £0.5.8 for two pairs. Finally he would carry on occasion a cane or an umbrella, as testified by the surviving bills.

He wore a gold watch; specifically, as we know from a bill for having it repaired in 1835, one made by Mudge and Dutton of London, no.1122. He may also have worn a ring, as there are references to 'Remounting cornelian in gold seal' in 1810, and to 'Engraving arms on red cornelian stone and mounting in gold' in 1828.

George Wightwick[12] gives a detailed description of Soane's appearance in 1829, which also tallies with that in the Lawrence portrait of 1828 (see page 60). It is interesting to note how old-fashioned he considered Soane to be in his dress by that date. 'He certainly appeared distinguished-looking: taller than common; and so thin as to appear taller: his age at this time about seventy-three. He was dressed entirely in black; his waistcoat being of velvet, and he wore knee-breeches with silk stockings. Of course the exceptions to this black, were his cravat, shirt-collar, and shirt-frill of the period. Let a man's "shanks" be ever so "shrunken", – if they be but straight, the costume described never fails upon a gentleman. The idea of John Soane in a pair of loose trowsers and a short broad-tailed jacket, after the fashion of these latter times, occurs to me as more ludicrous than Liston's *Romeo*! The Professor undoubtedly <u>looked</u> the Professor, and the gentleman. His face was long in the extreme; for his chin – no less than his forehead – contributed to make it so; and still more it appeared from its narrowness … A brown wig carried the elevation of his head to the utmost attainable height; so that altogether, his physiognomy was suggestive of the picture which is presented on the back of a spoon held vertically. His eyes, now sadly failing in their sight, looked red and small beneath their full lids; but through their weakened orbs, the fire of his spirit would often show itself, in proof of its unimpaired vigour.'

We may not know much about the toiletries employed by Mrs Soane, but she has left considerably more details of her clothes, a subject in which she evidently took much pleasure and interest. Indeed, although she refers on occasion to paying people for making garments for her, she made many of them herself, as she frequently records in her diary, probably gaining her inspiration from studying the numerous fashion plates published at the time.

Her undergarments consisted of a pair of long cotton drawers, a long shift or chemise of linen or cotton, a petticoat of light cotton, or fine wool in winter and a pair of stays: a laced under-bodice stiffened with strips of whalebone. Stockings of fine wool, silk or cotton which came up over the knee were held in place by garters. There are many references in her letters and diaries to gowns, or dresses, which she made for herself. Paper patterns were generally unavailable at the beginning of the nineteenth century, and the usual method was to unpick an existing garment as a pattern, tracing the pieces out on thin paper, or on the lining fabric of the new garment. The recommended way to make a dress was firstly to cut out and fit the lining. Though of course fashion varied a little each year, generally speaking for the first fifteen years of the nineteenth century dresses were what we now term 'empire-line': high-waisted, with a long skirt to the ground, a low neckline and short sleeves, which were generally puffed. For daytime or less formal wear the bodice was generally higher and the sleeves long. 'Bought 5½ yds of check for short gown cost 16/-' she records on 4 March 1805; 'Dined at Ly Beechey, put on new sarsnet gown' (sarsenet was a fine soft silk material) on 1 December 1805; 'Dined at Mr Braham's, spoiled blue gown' on 31 March 1806 and 'Began to make stript [ie. striped] gown' 'Finished stript gown' on 4 and 7 April 1807. Her dresses were often decorated with ribbon at the waist, with lace or with bugles

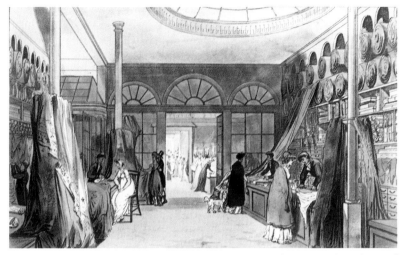

Messrs Harding, Howell & Co., 89 Pall Mall, illustrated in *Repository of Arts*, 1809. This is the sort of shop at which Mrs Soane would have purchased her dressmaking materials.

(or cylindrical glass beads). Sleeves were sometimes made separately, to be worn with different garments; she records the purchase on 13 February 1804 of '¼ [of a yard] of muslin for best sleeves' and on another occasion of 'Work'd trim[min]g for sleeves'. She refers to the purchase of 'a belt' and 'a cotton belt'.

A kerchief was often worn around the neck and shoulders, and Mrs Soane evidently favoured brightly coloured ones, at least on occasion, as there are references in her diary to 'A red check[in]g Muzn. [presumably muslin] kerchief' and 'a blue check silk kerchief'. She also records on 8 May 1804 'Bought a colord check nazin handkerchief cost 2/6.'

Another fashionable garment for women at the beginning of the nineteenth century was the spencer: a close-fitting jacket or bodice of silk or satin cut on similar lines to the dress, with long sleeves and fastened high at the neck. Mrs Soane paid £1.3.0 for one on 13 March 1804. On 30 November 1805 she 'bespoke [a] Velvet Pelese and Jacket from Mrs Such'. The pelisse, another very fashionable garment, was a long mantle of silk, velvet or cloth reaching to the ankles and could be with or without sleeves.

Gloves were also worn, and she records in her diary on various occasions the purchase of a pair of yellow gloves, eight pairs of white gloves and a 'p[ai]r of w[hi]t[e] silk mitts'. Mitts were half-fingered gloves worn in the evening. One

A pair of richly embroidered gloves which belonged to Mrs Soane.

Bill for a bonnet, 1814.

pair of gloves always thought to be Eliza's still survives at the Museum. Of cream kidskin, and heavily embroidered (see page 51), they must have been passed down through her family, as they have recently been dated to between 1670 and 1700.[13] Out of doors, together with her spencer or pelisse, Mrs Soane wore a bonnet, and there are various references in her diaries to straw bonnets and to the purchase of different coloured ribbons for trimming them. In the morning she wore a ribbon-trimmed cap (see page 57), and in the evening, following the fashion of the day, she would often wrap a piece of silk material around her head in a sort of turban, usually to match her dress (see below and front cover). She must also, at least on occasion, have sported an ornamental head-dress of some kind, (these were usually powdered hair on a cushion or stuffing, dressed with gauze or ribbon), as on 8 December 1804 she records the purchase of 'a new head Dress of Henderson, recom[mende]d by Storace [Nancy Storace the singer] cost £1.15.0'. A small reticule would complete the ensemble, often made of the same material as her dress and headress. In this would be put such items as a small pocket handkerchief, some coins if she was to play at cards and perhaps a vial of smelling salts.

There are bills for a silver-bear muff and for a fur tippet, and in the summer she would carry a parasol and a fan.

No details of her shoes survive, but she evidently bought in quantity as she records in her diary for 1 March 1805: 'Went with Miss Dales to buy shoes, bought 6 p[ai]r cost £2.0.0.' They were probably heeless slippers in silk, satin or kidskin. On one occasion Soane records in his diary that after an evening with friends 'Mrs S. complained of cold (she had worn thin shoes).'

As far as jewellery was concerned there are references in her diary to 'large red beads', to pearls, and to a pearl cross, and in her husband's Account Journal to the purchase of earrings for his wife and a diamond necklace (see also front cover).

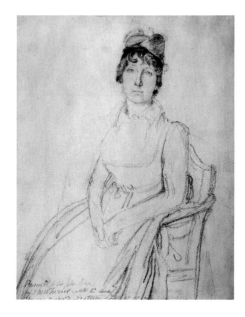

Pencil sketch of Mrs Soane by John Flaxman, c.1800. Note the way she has dressed her hair.

DAILY ACTIVITIES

Having arisen earlier, the family met for breakfast at about 9.00 am, a scene depicted in Joseph Gandy's painting of the Breakfast Room in No.12 Lincoln's Inn Fields of November 1798 (below). Toast or hot rolls and butter were consumed, and in the Gandy view we can see Mrs Soane pouring tea, made with water heated in an urn standing on the table. The two boys are playing to one side, and Soane is engrossed in a plan of Lothbury Court at the Bank of England, where he had been Architect and Surveyor since 1788. Letters were delivered in the morning, and indeed several further times in the day. There were two separate postmen, the 1d postman and the 2d postman, the latter delivering letters posted in London. Newspapers were also delivered to the house. Soane patronised a number of different local newsagents over the years, and purchased a wide variety of newspapers, the *Morning Post, The Morning Chronicle, The Times* and *The Examiner* being among them.

Breakfast over, Soane would retire to the office to allocate and arrange the day's work by the pupils. He might then retire to his Study (see Title page) to write letters and do his accounts. Clients might call to see him or alternatively he would visit

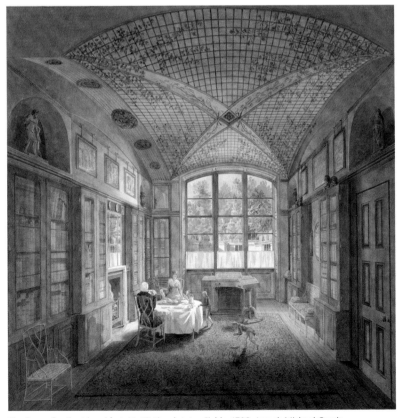

The Soane family at breakfast, No.12 Lincoln's Inn Fields, 1798, Joseph Michael Gandy.

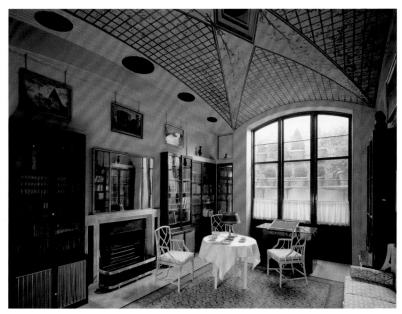

The Breakfast Room, No.12 Lincoln's Inn Fields today.

LEFT Bill for newspapers, 1809.
BELOW A London Postman from T L Busby's *Costume of the Lower Orders of the Metropolis*, 1819.

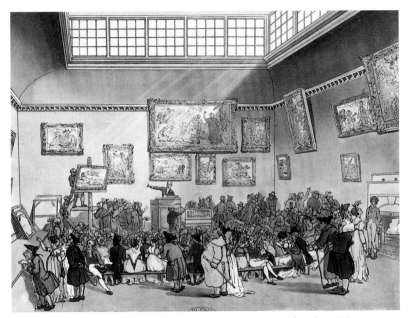

Christie's Auction Room, by Pugin after Rowlandson, from *Microcosm of London*, 1809.

them, which could be combined with any necessary site visits. He would spend some time in his office at the Bank of England on several days in the week, and likewise after 1807, when he was appointed Clerk of the Works there, frequent visits to Chelsea Hospital were necessary. Despite his busy professional life Soane also found time to indulge his passion for collecting, and he frequently went to view or bid at sales or spent time talking about the books he wanted to the various booksellers he patronised. Time too was spent arranging his purchases in the house and museum. For a total break from routine there was nothing he liked better than a day's fishing, either at Pitzhanger, or at Pangbourne or Chertsey (see Chapter 7).

Mrs Soane would retire in the morning to her Morning Room, a small room next to her Bedroom on the second floor. Here she would sit at her desk answering letters or sending out invitations. She would also discuss the day's menu with the Cook after breakfast, no doubt aided by her copy of John Farley's *The London Art of Cookery*, published in 1783, the year before her marriage to Soane.

Frontispiece of Mrs Soane's copy of *The London Art of Cookery*, published in 1783, the year before her marriage.

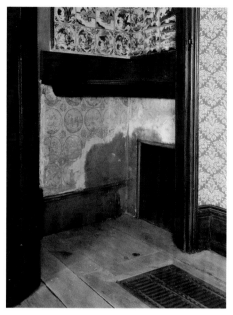

In the north-west corner of the Morning Room was a wash-hand closet in which has recently been discovered a rare surviving area of Dutch tile paper – an early 'sanitary paper', varnished to enable it to be washed down. There is also an ingenious small opening with a hinged cover which would have allowed a chamber pot to be passed through to the adjacent watercloset for emptying by the servants.[14] The blue and white tiles above the shelf for the wash basin are a later nineteenth-century addition.

Mrs Soane's Morning Room, of which we do not have a contemporary watercolour view, was filled with some of her favourite objects, including family portraits and a 'table with specimens of marbles . . . made for Mrs Soane, who latterly passed much of her time in this room' (1830 *Description of the House and Museum*). The novelist Barbara Hofland described the room in 1835 (Soane had preserved the room almost intact since Eliza's death in 1815) as 'so light and cheerful, so appropriately furnished as a retirement suited either for the purposes of study of of confidential intercourse'.

Later in the morning she might go out to order household equipment or provisions, pay tradesmen's bills or to fulfill commissions from friends living outside London, such as Lady Bridport, wife of Soane's client at Cricket St Thomas in Somerset. She might also, as we have already seen, get on with some dress-making, either for herself or for the boys – there are references to her making shirts for George and a dressing-gown for John. If she were spending the day at Pitzhanger, she might indulge in more domestic chores; on 4 Aug 1804 she recorded in her diary: 'At Ealing, bottled cherrys, out of doors all day', and there are several other summer references in similar vein.

In the afternoon, having changed her clothes, she would go out in the carriage or on foot to pay calls and visit some of her numerous female friends. They would often go walking in one of the parks such as Kensington Gardens, or drive a little further afield to Hampstead. Much nearer to home was the railed garden in the middle of Lincoln's Inn Fields, to which all the householders had a key. Here there were seats and shady trees and flowering shrubs to be admired (see page 12). Mrs Soane seems to have taken great pleasure in gardens. In their Lincoln's Inn Fields houses she had to be content with growing flowers and shrubs in pots, a number of which are to be seen decorating the outside window ledges of the houses in

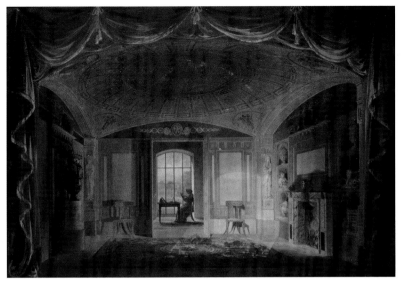

Design for the Breakfast Room at Pitzhanger Manor, 1802. Mrs Soane is shown seated at her writing table, wearing a ribbon-trimmed cap.

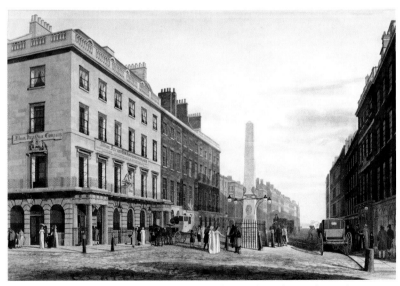

View of Blackfriars Bridge Road, looking towards Blackfriars Bridge, n.d. Note the crossing sweeper. Mrs Soane would have made afternoon visits in this area, as she had inherited property from her uncle in nearby Albion Place, and numbered several of the tenants among her friends. Both she and her husband had visiting cards specially printed for the purpose.

View from Hyde Park Corner, Frederick Nash, n. d.

the various contemporary views, but at Pitzhanger, as indeed at Soane's house at Chelsea Hospital, there were, as we have seen, extensive gardens where both flowers and vegetables were grown (see pages 13, 15 and 106).

She liked to visit art exhibitions with friends, and she bought pictures, which are still in the collection, at J M W Turner's Gallery and at Boydell's Shakespeare Gallery. Every spring she would visit the annual exhibition of the Royal Academy at Somerset House: 'Private view of exhib[ition] but I cannot go! Alas, poor Eliza,

The Exhibition Room, Somerset House, by Pugin after Rowlandson, from *Microcosm of London*, 1809.

you always went thither on this day' is the poignant entry in Soane's diary for 26 April 1816, six months after his wife's death. She also liked to read, recording in her diary on 17 October 1805: 'Paid for half a year's subscription to the Library in Tavistock Street £0.12.0.'

Lastly it must be recorded that some of her time was spent in charitable activity. Joseph Farington in his diaries records several instances of her interest in the welfare of the wives and families of Royal Academicians, and she made regular visits to the children in the Foundling Hospital. On 10 February 1807 she recorded in her diary that she had 'Called on Mrs Wilkinson ab[ou]t little girl', and the following day 'Got Wilkinson child into school and two boys into Sunday School.'

EVENINGS

Servants and workmen had their main meal at midday, but the family did not dine until half past four or five o'clock, or sometimes a little later on special occasions (dinner was eaten increasingly later as the nineteenth century progressed). The pupils went out to eat at around four o'clock, presumably in one of the numerous taverns in the area. Dinner was taken in the Dining Room, and they frequently entertained guests – friends and neighbours, and fellow Royal Academicians. Alternatively, they might go to friends' houses for dinner. Still to be seen in the Library and the Study are wooden racks with a space for each day of the week, into which Soane may have put his invitations (another possibility is that these were used by the servants to put the cards of people who had called when the master and mistress of the house were out or away from home). After dinner the company retired to the Drawing Rooms on the first floor (see page 63 and back cover) for conversation and frequently a game of cards. From time to time they would have a dance, music being provided by the pianoforte which Soane had purchased from Nancy Storace in November 1804. Mrs Soane was evidently much

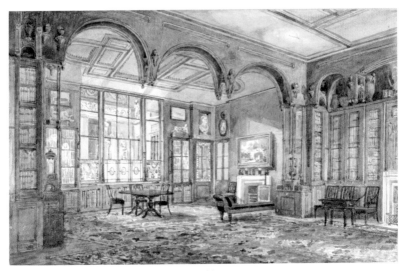

View of the Dining Room at No.13 Lincoln's Inn Fields, 1825.

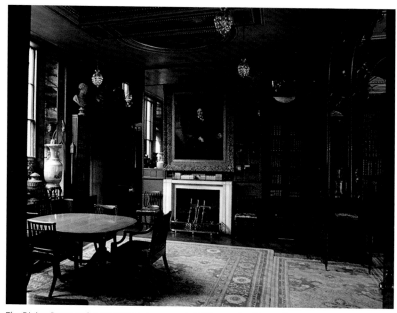

The Dining Room today. Sir Thomas Lawrence's 1829 portrait of Soane hangs above the fireplace.

fonder of this form of entertainment than her husband, as she records in her diary on 1 April 1812: 'Mr S. out of town. Had a little dance', and he in turn records somewhat irritably on another occasion: '[Mrs S] wishes to know when I go into the Country, [here he quotes his wife] want a small party which always puts you out of humour – I must therefore have them when you are from home! – indeed.' Tea was taken in the Drawing Room at about 8 o'clock, followed occasionally by supper at 10 o'clock. After the Monk's Parlour had been built in 1824, Soane sometimes took guests down there in the evening to drink tea, which was clearly regarded as a wonderfully atmospheric experience by one lady correspondent. The evening drinking of tea did not depend on having been invited for dinner, and often people would come for the express purpose of 'taking tea'.

Soane often had to attend official dinners, with the Royal Academicians for instance, or the Directors of the Bank of England, the Freemasons or the parish Vestry. These were usually held in one of the many City coffee houses or taverns. On many evenings he also had to work, either at preliminary plans for new projects or reading and making notes in preparation for the lectures he had, as Professor of Architecture at the Royal Academy, to give to the students of architecture. On such occasions Mrs Soane might go out with friends, but at other times she stayed in and helped by making fair copies of notes for him or at tasks such as 'paging books'. She also stuck into albums for him the newspaper cuttings he had marked on subjects in which he was interested, such as current affairs and architecture.

One great pleasure they evidently shared was a visit to the theatre. This was something that had started before they were even engaged: on 24 February 1784 for instance Soane records: 'At the Play, Miss Smith, "All in the Wrong", "Knights",

One of a pair of knife-boxes which stood on the sideboard in the Library-Dining Room (see Contents page).

Bill for replacing knife blades, 1826. The cartouche at the top of the bill illustrates how the knives were stored within the box.

A selection of pieces from one of Soane's dinner services. Made of Coalport porcelain, it was produced about 1805–10 at the Anstice, Horton and Rose factory. The object at the top right of the picture is an ice-pail, for cooling fruit. Two of these can be seen in the South Drawing Room at No.13 Lincoln's Inn Fields.

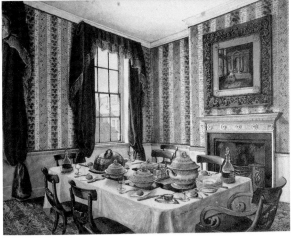

Watercolour by Mary Ellen Best showing the table laid for dinner at her Yorkshire home, 1838. Each place has a bread roll lying on a napkin. Note that the wine glasses are placed on the left of each place-setting, and the spoons are inverted.

A humorous request from Mrs Chantrey, wife of the sculptor Francis Chantrey, for a reply to her invitation to dinner. '*Pray Mr Soane favor me (Mrs Chantrey) with an answer to a note sent last Wednesday inviting you to dine here on Tuesday next the 1st of August ½p6'*.

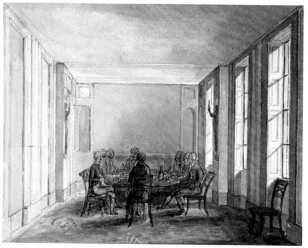

A group of men dining, n.d. The cloth has been removed, and they are settling down to dessert. The location has not been identified, but one can imagine many similar scenes having taken place over the years in Soane's Dining Room.

"Maid of Oak"'. There are numerous references in the diaries of both to having seen plays such as *Honey Moon, False Alarms, The Wood Daemon, Heir at Law* and *The Magpie*, and to specific actors such as Master Betty in *Lovers' Vows* or *Barbarossa* and Kean in *Shylock*. Sometimes one or both of the boys accompanied them. They also liked to go the the Opera, and to musical events such as 'the Oratorio' and 'Mr Heaviside's concert'. Spectacles such as those to be seen at Sadler's Wells and Astley's Amphitheatre were also enjoyed. Mrs Soane enjoyed visits to Vauxhall Gardens, the pleasure gardens near what is now Vauxhall Park, but her husband was, perhaps predictably, less keen, noting in his diary for 2 August 1799: 'Mr and Mrs Malton and Macklew dined and dragged me to Vauxhall . . . ret[urne]d ¼ past 2.'

View of the South Drawing Room, 1825.

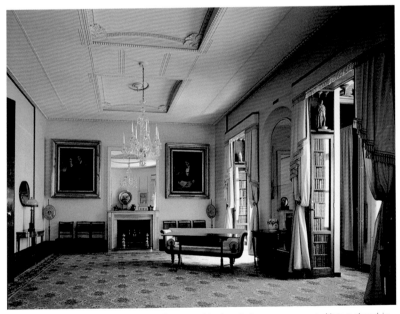

The South Drawing Room today. The balcony outside the windows was converted into a closed-in loggia in 1834.

A theatre bill of 1821.

Soane continued to enjoy visits to the theatre after his wife's death, but it took some time before he felt able to resume them: 'Went to see Macbeth by Mr Kemble and Mrs Siddons' he recorded on 5 June 1817, 'Charles Kemble's benefit . . . 1st time of going to a play.'

Other favoured evening outings were to drink tea in a tea garden such as that at the Gipsy House, Norwood, or to go somewhere to eat ice-cream. Or a walk might be taken such as that recorded by Soane in his diary for 23 May 1814: 'After dinner walked with Mrs S. by the New River – into Islington and ret[urne]d home by Grays Inn Lane.'

11. I am grateful to Tim Knox for this suggestion.
12. See note 9 on page 43.
13. I am most grateful to Douglas Sweet of the Worshipful Company of Glovers for researching and dating these gloves.
14. I am grateful to Mark Sandiford and David Eveleigh for this information.

View of a play in progress at the Italian Theatre, Haymarket, by Antonio Van Assen, 1793.

Detail from an engraving of an equestrian entertainment in progress at Astley's Amphitheatre, 1815.

5

FOOD AND DRINK

Mealtimes

As we have already seen, breakfast consisted of hot rolls and butter or toast and tea or coffee. If Mr and Mrs Soane ate anything at all in the middle of the day there is no record of it, and it will only have been the lightest of snacks. It was not customary at this date to eat a formal meal in the middle of the day, except for servants and workmen.

Dinner was the main meal of the day, served at about 4.30 or 5.00 pm. It consisted of two courses followed by dessert. All the dishes were laid out together on the table in a precise symmetrical arrangement (see below). The first course consisted mainly of meats cooked in various ways, together with some vegetables. If a soup was being served, usually accompanied with bread rolls, this would be eaten first and removed and a fish dish put in its place. The meat was served after the fish. The table was laid with two table clothes, one of which was removed between courses or before the dessert. The second course consisted of lighter dishes of meat and fish, together with sweet pies, puddings and tarts. Dessert consisted of jellies, sweetmeats, fruit, nuts and sometimes cheese. Mrs Soane would have sat at the top of the table and her husband at the bottom and each would carve the dishes before them at each end of the table and help their guests, when they had them, to these. The guests would then help themselves and each

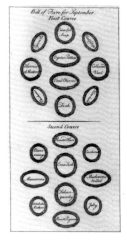 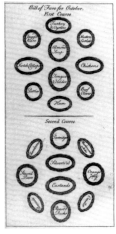

FAR LEFT Detail from *Fish*, aquatint from the London Markets series by Dubourg after James Pollard, 1822.
LEFT Suggested menus for different months from *The London Art of Cookery*, showing the way dishes were laid out on the table.

other to the rest of the dishes laid out on the table. The role of the Butler and Footman was to change the plates and remove courses and to pour wine, which was done from the sideboard. The current custom of each person at table being served individually, 'Diner à la Russe' as Mrs Beeton called it, was just beginning to come in in the first quarter of the nineteenth century, but it was very slow to be widely adopted.

After dessert had been removed and a glass or two of wine drunk the ladies withdrew to the Drawing Room, where they were joined later by the men for conversation or card games as has previously been discussed.

Place settings seem to have been laid in much the same way as today. In the early nineteenth century finger glasses were introduced, which would be filled with water for the diners to dip their napkins into to cleanse their fingers and mouth. Soane also owned a set of glass coolers – glass beakers with pouring lips on each side, one for each place, in which one or two wine glasses could cool in spring water as the meal progressed. In later life at least, when presumably his nerves could be irritated by unnecessary noise, the glasses were placed on doilys – small ornamental napkins of a coarse woollen material fringed at each end. We know this because of an interesting, though not completely decipherable passage in his diary where he records that having been given a present of '6 d'oyleys for the water dishes', he tried one of them and found it 'suceeded admirably, no noise from the plates' but two days later when Mrs Conduitt dined with him she noticed them and was very displeased, presumably because it constituted interference with her management of the house.

MEAT

A wide variety of meat, game and poultry was eaten in the Soane household: beef, lamb, mutton, hare, turkey, chicken, venison, veal, pheasant, grouse, partridge and duck. The availability of venison was usually taken as an opportunity for entertaining, even for giving 'venison parties'. Kidneys were eaten, as also some parts of the animal less familiar to us today such as 'lamb's fry', lamb's and calf's head, calf's heart and calf's foot. Hams were frequently consumed, but pork rarely so to judge by the surviving accounts. Pigeons featured quite frequently on the menu, though rabbit only occasionally. Game less common today such as widgeon and woodcock was also eaten. Sausages appear in the accounts from time to time and there is one reference to '5lb [of] German sausage'. There seems to have been greater awareness of breeds than is generally possessed today. Writing to his son John at Christmas, a time when turkeys and other game were frequently given as presents, in 1820, Soane apologised for the fact that 'I have no white turkey sent me this year, I therefore request your acceptance of the largest I have of a different breed.' Some meat was purchased specifically for making soups or stocks, and there are references to 'gravy beef' and 'larding fowl'.

Meat was cooked in one of three basic ways, boiled, roasted or broiled. Boiling was done in a large cast-iron pot hung over the fire, and boiled beef and carrots was a common dish. Roasting was done on a spit before the fire over a dripping tray to catch the juices. It could also be done in a hastener, or reflector oven, with one side open to the fire. Broiling was very popular; that is to say cooking over the open fire in a cast-iron frying pan or a gridiron or griddle with a long

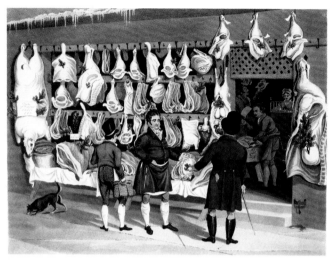

Meat and Poultry. Two aquatints of London Markets by Dubourg after James Pollard, 1822. The top picture is set in wintertime and the bottom in the summer.

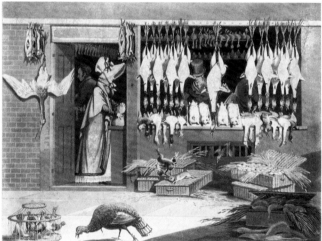

Bill for a saddle of mutton, 1824.

DEVONSHIRE HOUSE.

London, 182

Bought of WILLIAM TUCKER,

Cheesemonger, Poulterer, and Porkman,

DEALER IN FRESH, DORSET, AND DEVONSHIRE BUTTERS,

286, STRAND, nearly opposite Norfolk Street.

A supply of Fresh Butter and the real Devonshire Clouted Cream every morning.
The real Oak-hampton or Venison Mutton, and fine Fresh Laver, when in Season.

handle. Mutton chops or beefsteak, which appeared frequently on Soane's table, would have been cooked in this way. Meat was also eaten cold, particularly in hot weather. It was also made into pies, and dishes such as ragouts, fricassees and curries. It might also be cured: there are references in the household papers to pickled tongue and hung beef – that is beef cured in brine with saltpetre, hung in a chimney where wood was burnt to dry and then boiled. Such cures would allow meat to be kept longer than was otherwise possible without the refrigeration we take for granted today. Despite being purchased virtually daily and kept in cool conditions in meat safes in the airy passage outside the Kitchen, meat still went off and there are occasional references to this in Soane's diary, such as that of 22 March 1818: 'Mr J. Soane [his son] and Mr and Mrs Conduitt dined here, bad veal and worse Baron [beef]: it was not so in former times but!' [in other words, before the death of his wife], or the entry recorded on 20 August 1822: 'Mrs Conduitt dined with me on stinking Fish and Roast Chicken.'

FISH

Many varieties of fish were served: salmon, mackerel, haddock, whiting, sole, turbot, herrings, smelts, mullet, dorey, skate, sprats, eels, pike, tench and carp, the latter three often caught by Soane himself. Oysters were plentiful and not expensive. Prawns and lobsters were served on special occasions, and most commonly boiled or simmered in a brine of water and bay salt (the French salt from seawater used for preserving) to be eaten cold. Another related food which was a great favourite for celebrations was the green sea turtle imported from the West Indies. Turtle dinners were extremely popular in the first quarter of the nineteenth century. Soane attended a number with, for instance, his fellow Freemasons at the Freemasons' Tavern, and would also on occasion send to the Tavern, nearby in Great Queen Street, for turtle or turtle soup for consumption in his own home. The turtle's belly and back were boiled and baked respectively and laid out at the top and bottom of the table, the fins and guts were stewed in rich sauces to provide corner dishes, while a tureen of turtle soup, made from the head and lights, had the place of honour in the centre.[15]

Like meat, fish too might be cured, and there are references to 'pickled salmon' and 'pickled oysters'. There was, of necessity, much greater awareness of the seasonality of foods. Most of us are aware today of the season for strawberries or asparagus, or even oysters, but how many of us would know that cod's head, or 'cod's scull' as it appears in Soane's diaries, which was considered something of a delicacy, was in season in December and January?

Fish was usually fried in egg and breadcrumbs or poached in

Bill for 2lbs of Gloucester salmon, 1818.

a fish-kettle. A popular recipe for perch for instance, called for it to be cooked in a mixture of water and milk with parsley and sliced onion. This was then served with butter and parsley in a sauceboat, with or without the onion. A variety of commercial sauces, principally for serving with fish, was available by the nineteenth century, and purchase of these features prominently in Soane's household accounts. The bills record Anchovy Essence, Reading Sauce, Portland Sauce and Lemon Pickle. The basis of a lot of these sauces, together with vinegar and spices, was India soy, which was also purchased on its own as Soy Sauce. Frames or condiment sets were purchased to hold these sauces at table. Mushroom ketchup (or catsup) was another favourite, and we know from her letters to him that this was often made for Soane as a present by Miss Archbold, a family friend who lived in Brighton.

VEGETABLES

Vegetables were supplied by the numerous market gardens that ringed London. The commonest vegetables consumed were probably green beans, carrots and green vegetables including cabbage, spinach and sea kale. Asparagus was eaten in great quantities during its brief season, and we know that artichokes were eaten as Mrs Soane records in her Account Book in 1805 the purchase of '6 artichoke cups'. Some clues as to the accents of Soane's servants can incidentally be gleaned from the records of these purchases in the Cook's book – 'sparrowgrass' for asparagus for instance, and 'Sallery' for celery. The latter, which we generally eat raw today, was often cooked, as were cucumbers. Onions were used, and there are mentions of 'Spanish onions' and 'Portugal onions'. They were another foodstuff commonly sent as gifts. Peas were greatly enjoyed for a brief season. In the minutes of the Trustees of Lincoln's Inn Fields for June 1794 there is a complaint that the rubbish is not being taken away frequently enough from the houses in the Square by the scavenger 'especially inconvenient at this time of year because the bins are filled with pea-shells and other vegetable rubbish'. Broccoli is mentioned in the Cook's Books, as are parsnips, turnips, turnip tops and 'Cutt Roots'. Potatoes, however, feature rarely, and were not the dietary staple they are now, or at least not among the wealthier classes in the towns of the south. Apart from bread, starchy filling was provided by a wide variety of boiled or baked 'puddings' usually of suet or pancake batter.

Some of the vegetables would have come from their gardens at Chelsea and Pitzhanger. In his Pitzhanger Account Book Soane records planting 'Charlton Pease [Peas] and Dwarf marrowfat pease, early forcing kidney potatoes, Strasbourg and

Bill for various prepared sauces, 1820. Note that there is a reduction for returned bottles.

white onions, long pod beans, York and Savoy Cabbage, Curled and Early Purple Caile [Kale], Gawse and Cabbage lettuce, Long Orange and Early Horn carrots, parsnips, early Dutch turnips, sallad celery, cauliflower, red beet, leeks, and spinage [spinach].'

Salads of various in-season greens and vegetables such as radish, were eaten, usually served with hard-boiled eggs rubbed finely together with oil, vinegar, mustard, pepper and salt. The 'sallet oil' was olive oil.

Parsley was used a great deal, as also were herbs such as mint, thyme, savory and sweet marjoram. Capers were frequently put in sauces for fish or mutton and horse radish was also used for sauces or for grating over the oilier fish such as mackerel, herrings or salmon.

The most usual sauce for vegetables was melted butter, either on its own or stirred into a paste of flour and water, indeed a great deal of butter was consumed.

DAIRY PRODUCTS

Of the other dairy products, eggs were mainly used for cooking, although Mrs Soane does refer in her diary to buying egg cups. There is also one reference to the purchase of plover's eggs. Eggs were clearly regarded as suitable invalid or convalescent food, as Soane refers on one occasion to sending for new-laid eggs for Mrs Conduitt as she had been ill. Milk was used only in cooking, and never drunk by itself, except by infants. The milk sold in pails around the streets of London by milk-girls was very contaminated, and often watered down.

HERBS AND SPICES

Seasonings used in both sweet and savoury cooking in the Soane household were cloves, ginger, chillies, cinnamon, allspice, nutmeg, mace, cloves, mustard, salt and pepper, both white and black and cayenne pepper. These were relatively expensive ingredients and stored carefully. Nutmegs were grated on small tin graters which had a receptacle at one end to hold the nutmeg, pepper was milled in a pepper mill, and salt kept in a wooden box with a lid near the fire to keep it dry. Other spices had to be ground up in one of the number of pestles and mortars of different sizes that formed part of the kitchen equipment.

SUGAR AND OTHER DRY GOODS

A variety of other dry goods was purchased from the grocer. Sugar came in large cones or loaves which had to be broken up into lumps using cleavers and sugar nippers (see page 76). Moist sugar – unrefined or partially refined sugar – was also much used in baking. Currants and raisins were used in puddings, and there is one reference to sultanas. Candied oranges and lemons were used particularly at Christmas time to make an extra rich pudding.

Soups were thickened with bread, flour, oatmeal, pearl-barley, rice, macaroni and vermicelli (or 'Vermassely' as it appears in one entry in the Cook's Book, thereby giving a clue as to its customary pronunciation). Sago and ground rice also appear frequently.

FRUIT AND DESSERTS

Fruit was used in two ways, both fresh for dessert or stewed and cooked in pies and tarts. Fruit such as cherries were often bottled when they were in season for use later in the year. Favourite dessert fruits were oranges, pineapples, strawberries, peaches and occasionally grapes. Quinces, rhubarb, damsons, plums and apples all featured on the menu, and the juice of lemons was of course used for flavouring.

Creams, jellies and ices were very popular for dessert. Jellies were made using isinglass, a type of gelatin, fruit, sugar and occasionally brandy. Savoury jellies were also made. Ices, however, had to be sent out for. For many years the Soanes patronised Mr Groom, Confectioner at 16 Fleet Street, nearby, who supplied them with jellies, cakes and pastries, savoury as well as sweet. Their favourite flavour of ice seems to have been pineapple, closely followed by strawberry, and blackcurrant and orange are also recorded. As far as nuts are concerned, the purchase of walnuts is recorded, as also almonds which

RIGHT Bill for confectionery, 1820.
BELOW *Fruit* from the London Markets series, 1822. The scene is probably set in the autumn.

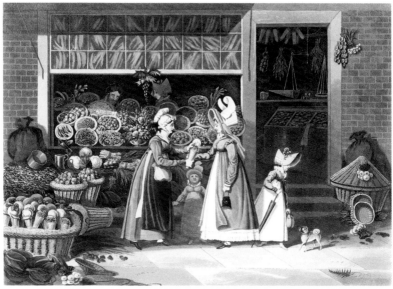

Bill for parmesan and gruyère cheese, 1819.

would have been used to cook with. Stilton and cheddar cheese were regularly purchased, as also were parmesan and gruyère. On one occasion Soane was sent '¼ doz[en] neufchatel cheese' as a present. Some of the cheese purchased would have been used for cooking, of course, and the Cook's *batterie de cuisine* included a cheese toaster – a fork for toasting cheese.

EVENING TEA

With tea, later in the evening, biscuits or cakes might be served. There are also two mentions of sandwiches. These came in in about 1765, and were said to have been named after John Montagu 4th Earl of Sandwich (1718–92) who once spent 24 hours at the gaming table sustained only by some slices of cold beef between pieces of toast. On 10 December 1804 Mrs Soane recorded in her diary: 'At Mrs Bushman's, a small party, eat sandwiches' and in April 1816 Soane noted: 'Mrs Conduit[t] and Mrs Hofland to tea and sandwiches.' *The Complete Servant* by Samuel and Sarah Adams of 1825 recommends: 'Sandwiches should be neatly cut in mouthfuls, so as to be taken up with a fork.'

MENUS

Although we have a great deal of information about the food purchased and indeed the guests the Soanes entertained, the combinations of food served at individual meals are unfortunately not frequently recorded, particularly in the years of Mrs Soane's lifetime. Nor is absolutely every dish mentioned. Joseph Farington illuminatingly records the makeup of a number of meals in his diaries but none, unfortunately, of those he ate at Lincoln's Inn Fields, although he does record the seating plan on several occasions. Clearly the lavishness or otherwise of the meal would depend on whether or not guests were being entertained. Some combinations recorded by Soane are: 'Salmon, Leg of Mutton [and] Pudding' when Dr Breedon and Mr Westall were being entertained on 28 September 1802; 'Cod scull, shoulder of mutton, plane (sic) boiled dumplings [and] sweetbread' eaten with Mrs Conduitt on 10 December 1823, and when dining alone at various times 'Boiled mutton and broth', 'Neck of lamb and beef', 'Bacon, pease and

mutton chops' and 'Beefsteak'. On 11 September 1823 he recorded: 'Dined alone, stinking boiled beef, sent for oysters.' Interestingly, on Sunday 17 April 1831 he records: 'Mr and Mrs C[onduitt] dined here – Fish, Roast Mutton & Plumb (sic) Dumpling – a Sunday's dinner.'

TEA, COFFEE AND CHOCOLATE

Tea was the main non-alchoholic beverage consumed by the Soanes. Tea was imported only from China at this date and was either black or green. It was drunk weak, often with the addition of sugar. The Soane's favourite variety, to judge by the surviving bills, was Souchong. Hyson, a green tea, appears quite frequently too. There is one isolated reference to buying 'Strong Congou Tea', a black china tea. The Soanes purchased their tea from a variety of sources, but most frequently, as many of their groceries, from John Jordan who operated 'At the sign of the Cocoa Tree' at 302 High Holborn. The sign, which is illustrated in his engraved bill-head (see page 76) was probably a large Coade Stone sign hanging outside the shop.[16] Tea was an expensive commodity, and was kept under lock and key by the mistress of the house or the Housekeeper. The drinking of tea was a social occasion with supporting rituals. The mistress of the house presided over the tea table, taking the tea from a locked wooden caddy and making it in a teapot with boiling water heated in an urn or in a kettle heated by a spirit lamp. The servants, too, drank tea, as was becoming common among the poorer classes when they could afford it. On one occasion Soane gave his servants a present of tea.

WHOLESALE TEA WAREHOUSE
302, High Holborn.

J. JORDAN most respectfully begs leave to inform the Public, that the EAST INDIA COMPANY'S Quarterly TEA Sale is just concluded : they are a good Parcel of Teas, but went somewhat higher than at the former Sale. J. J. submits a List of Articles, which, for Quality and Flavour, shall not be surpassed by any House in London, at their respective Prices.

TEAS.

	s.	d.			s.	d.			s.	d.
Good Bohea	5	2	Very fine Souchong	9s. to	10	0	Hyson Kind	8s. to	9	0
Congou Kind	5	6	Finest Pekoe		11	0	Good Hyson		10	0
Good Congou	6	0	Padrea in Packets.				Fine ditto		10	6
Good rough-flavoured ditto	6	6	Fine Caper	8s. to	10	0	Very fine	11s. to	12	0
Fine ditto	7	0	Green Tea		6	0	Fine Cowslip		13	0
Fine Souchong	7s. 6d. to 8	0	Good ditto	6s. 6d. to	7	0	Fine Gunpowder	14s. to	16	0

N. B. The following will be found better at their respective Prices, than are sold by any other House.

	s.	d.			s.	d.			s.	d.
Congou Tea	6s. 6d. to 7	0	Green Tea	6s. 6d. to	7	0	Hyson Tea		10	6
Souchong ditto	7s. 6d. to 8	0	Hyson Kind		8	0	Ditto	11s. to	12	0

J. Jordan most earnestly begs leave to return his best thanks to the Public, for the decided preference he has experienced since he has sold single Pounds of Tea at Wholesale Prices, and most respectfully assures them he will continue to sell a superior Quality to what is sold by any other House, at the above Prices.

COFFEES.

	s.	d.			s.	d.
Plantation Coffee	2	0	Bourbon Coffee		3	0
Fine ditto	2	4	Genuine Turkey ditto		3	6
Java ditto	2	8	Ground Cocoa, *warranted genuine*		4	8

Families supplied with Raw Coffee on the best Terms.

Advertisement showing the range of teas and coffees stocked by John Jordan, 302 High Holborn, 1817.

Bill for loaf sugar and coffee, 1816.

Bill for 8lbs of loaf sugar. Sugar came in large cones or loaves which had to be broken up into lumps using a cleaver and sugar nippers.

Coffee was also drunk at Lincoln's Inn Fields, but less frequently. The surviving bills all specify 'Turkey Coffee'. It was purchased in the form of beans which were then ground using the coffee mill in the Back Kitchen. Like tea it was probably drunk sweetened. There are, too, a few references to the purchase of chocolate. This was bought by the pound weight in a cake or a roll and had to be grated into hot liquid, water or water and milk, in a chocolate pot and then swizzled with a notched stick called a chocolate mill.

ALCOHOLIC DRINKS

As we have seen, the servants of the household drank varieties of beer, ale and porter, and also gin, usually diluted with water. Beer, too, is often recorded as being purchased as a reward for workmen, like those, for instance, who installed the large plaster cast of the Apollo Belvedere in the Musuem, or for the workmen engaged on one of Soane's building sites to celebrate some event of national significance such as the victory at the Battle of Waterloo. There are also references to Porter 'for Mr Payne', Soane's Clerk of Works at the Bank of England.

Mr and Mrs Soane drank wine with their meals. Mrs Soane may well have watered hers down, as it was the custom of some ladies to do at the time. The varieties purchased very much reflect the political situation in Europe at the time. For much of the period with which we are concerned the Napoleonic Wars were raging and French wine became difficult and expensive to obtain, which substantially boosted the trade with Portugal in particular. Preferential duties had in fact been allowed to Portuguese wines since the beginning of the

eighteenth century. Red Port wine was perhaps the biggest item of consumption in the household. One must remember that it was then a dry table wine, and not the heavily fortified wine of today, although a small quantity of spirits was sometimes added to preserve it during the long sea journey. Soane also favoured a white Portuguese wine called Lisbon and a sweet white wine also shipped from Lisbon called Calcavella. Another favoured dessert wine was Mountain wine from Malaga in Spain, which was brown and sweet, like the Madeira which he also enjoyed which came from the island of the same name. Also from Spain was sherry wine, again not as fortified as that of today. Some of his sherry came from the East Indies, where it was sent from Spain, the long sea voyage having been discovered to improve the ageing process.

Of the French wines recorded, Soane's favourites seem to have been red burgundies: Chambertin and 'Nuits Burgundy' are specifically mentioned. Also recorded are Red Hermitage from the Rhone and Côte Rotie. Soane also greatly enjoyed drinking champagne, his favourite being that produced by the ancient house of Ruinart. The bills refer both to red and white champagne: both white and rosé were produced. Not all champagne was sparkling at this date. Sillery for instance, which we know Soane ordered (it is described in the bills as 'Sellerz Champagne') was described thus in 1809: 'At Sillery and Verzenay we have always made white wines entirely from black grapes. They are vinous, full-bodied, and their colour is generally brown or stained. These wines should be non-mousseux'.[17]

Wine was bought by the bottle, in dozens or half dozens as today. But more often than not larger quantities were purchased. Port was purchased by the pipe (a large cask) and bottled on site. A bill of 18 August 1808 from W & J Whitmore details: 'One pipe of Red Port Wine containing 52 doz. and 3 bottles, bottling, corks, packing and unpacking, loading and unloading, laths and sawdust, washing bottles, cartage, 5 doz. bottles not returned, unbinning and binning 90 doz. of wine in Mr. Soane's cellar.' Supervising these operations was the preserve of the Butler, who would, when the wine was later called for, have to decant it using a wine funnel and a strainer. Sherry similarly came in a butt.

There were formalities associated with the importation of wine from abroad. In July 1802 Edmund Norman presented a bill for 'Duties paid on a pipe of Madeira

Bill for wine, including champagne, from Ruinart & Sons, 1831.

per the Louisa, lighterage, wharfage, cartage to Excise Wharehouse, warehouse rent, fees etc. To Cooper petitioning excise, passing entries, clearing entries etc.' Similarly in September 1815 Soane was issued with a permit from the Excise Office to 'receive 567 [bottles] of foreign white wine from the stock of Olive & [Britten]'. Sometimes, too, he would share these costs with a friend or friends. In April 1816, for instance, he paid Mr Keate, a friend at Chelsea Hospital, for 'the 4th part of a barrel of Burgundy, including payments in France, duties etc.'.

Brandy was usually purchased by the gallon. It was drunk by itself, but also used as the main ingredient in punch, a favourite drink for social occasions and always drunk at turtle dinners. Recipes varied considerably, but a typical one might consist of brandy, water, lemons (or sometimes limes), sugar, nutmeg and wine such as claret or malaga. Soane very often bought his ready bottled from the proprietor of the Freemasons' Tavern in nearby Great Queen Street.

Other liqueurs represented among the surviving bills are bottles of White Noyau, a liqueur of brandy flavoured with fruit kernels; Cherry and Apricot Brandy, Rum Shrub and Brandy Shrub, a cordial made of fruit juice and spirit; Curacoa [Curacao], a liqueur of spirits flavoured with the peel of bitter oranges and sweetened and Maraschino, a liqueur distilled from the marasca cherry.

Very few of the wine glasses from which these wines would have been drunk have, unfortunately, survived. Nor are there many references among the bills to their purchase, although there is a bill of 1816 from William Woodcock of the China & Glass Warehouse, 42 Great Queen Street for '6 Cut Champagne Glasses'.

Finally, by the 1820s there are bills for soda water, purchased in glass bottles from S Deane and Co. at the Mineral Water Warehouse, 54 Mortimer Street. Soda water was seen as an aid to digestion and a corrective of digestive ailments.

CHRISTMAS

Let us now consider how the family celebrated Christmas. Christmas was not celebrated in exactly the same way in the late eighteenth and early nineteenth centuries as now, but a surprising number of the familiar customs had already been established. The Victorians and Prince Albert are usually credited with introducing the modern Christmas, and it was not until 1843 that the Christmas card was invented, but Christmas trees were introduced to this country by Princess Charlotte of Mecklenberg-Strelitz when she married George III in 1761, although their use does not seem to have caught on in any big way until Victoria and Albert adopted the custom at Windsor. Long before that there had been a tradition of decorating houses with holly and ivy at Christmas time, and of feasting and merry-making. Traditionally presents had been exchanged at New Year, and the custom of giving them at Christmas is again said to have been due to Princess Charlotte.

There was not the long lead up to Christmas that there is now. Richard Rush, Envoy Extraordinary and Minister Plenipotentiary from the United States from 1817 to 1825, writes of 24 December 1817: 'Being the day before Christmas there was more display in the shops than usual.' Soane's office shut down briefly at Christmas and his pupils had Christmas and Boxing Day off, and sometimes also December 27th. This, however, did not stop Soane working, and he seems to have worked on most Christmas Days – writing letters, settling accounts or drawing

plans. On 25 December 1797 for instance he records: 'At home all day ab[ou]t Bank Drawings.' Occasionally he even visited people on business.

Mrs Soane often seems to have visited the children at the Foundling Hospital, either on Christmas Day or soon after, usually in company with her friend from Chertsey, Sarah Smith. Then at 4.00 pm they sat down to dinner, usually with a number of guests, although in 1804 Mrs Soane merely records:

Two net purses made for Soane by his grand-daughters Elizabeth and Maria, Christmas 1829.

'At home all day, Mr Turner dined here.' In 1806 they played host to Mr Carter, Mr and Mrs Kinderley, Mr and Mrs Foxhall and children and Mr Adams, and in 1810 Mrs Soane records: 'Wet day – dined here Foxhall 5, Britton 2, Smith 1, Buxton 1. F. Foxhall and Miss Smith slept here.' In 1811 Soane records that they entertained 'Mr and Mrs Ned and Fan Foxhall, Mr and Mrs Britton, Mr and Mrs Kinderley, Mr Braham and Madam Storace and John Soane.' John Braham and Nancy Storace were well-known singers (Nancy had been the first to sing the role of Mozart's Susanna in *Il Nozze di Figaro*) so one can imagine there may have been some musical entertainment after dinner, upstairs in the Drawing Rooms.

The twelve days of Christmas (from 25 December to 6 January) were traditionally a time for entertaining and getting together with friends, and both Mr and Mrs Soane's diaries record a number of evenings spent thus. The days do not seen to have been so much fun for Mrs Soane with her husband firmly back at work; she records on Boxing Day 1805: '. . . at home alone all day – went into the Warm Bath'. On several occasions she took the two boys to Ealing after Christmas, or to her relatives at Chertsey, getting together with her husband again at New Year. On New Year's Eve 1805 Mrs Soane records: 'Went in the Evening to Mrs Kinderley, a very pleasant evening, stay'd until 1 o'clock.' Whether or not Soane went with her is not clear for in several years Soane records on New Year's Eve that he dined at the Royal Academy 'according to ancient usage at 6.00 pm'. On 1 January 1796 Soane records: 'At the Play with Mrs S. and the boys £0.14.0.'

Sadly Mr and Mrs Soane's last Christmas together in 1814 must have been marred by worry about their son George who was in the King's Bench Prison for debt. On 22 December George wrote to Soane threatening to commit suicide and on Christmas Eve the Under Marshall of the prison called at the house and left a bottle of poison which had been taken from George!

Christmases after Mrs Soane's death in November 1815 were very gloomy for Soane, at least for some years. On 25 December 1815 he records: 'Went to Chelsea and took Miss Smith. Dined at Mrs S. Passed a gloomy day', and on Christmas Day 1816: 'Mr and Mrs Britton dined here! Only two, how changed my state.' In subsequent years Mr and Mrs Conduitt seem to have dined with Soane on Christmas Day. In 1819 he records: 'Thick fog. The 4th miserable Christmas Day', and it was on Christmas Day in the following year that Fanny, one of the

last links with his wife, died. Things seem to have improved after this, however, and he records more evenings out. On 30 December 1820 he records: 'Dined at Mr Mitchells, Mr Braham, Mr Goldsmith, Mr Martyn and son, Mr Chas. Kemble. Bro[ug]ht Mrs Kemble to C[ovent] G[arden] Theatre.' On Christmas Eve 1821 he dined with a number of others at Kensington Palace with the Duke of Sussex where he 'showed the Duke a plan for the entrance into the Gallery at the Freemasons', and on New Year's Eve in the same year he dined with his neighbours at No.12 Lincoln's Inn Fields, the Tyndales, along with Mr Coomb, Mr Wilson and son, Mr, Mrs and Miss Gurney, Mr and Mrs Pullen (neighbours on the other side) and Mrs Blight.

There is, unfortunately, little evidence about Christmas presents. Apart from the net purses Soane was given by his grand-daughters in 1829 (see pages 79 and 87). the only other reference so far found is on 14 January 1818 when Soane records: 'Gave Mrs Conduitt a pocket Almanack [a sort of diary], my usual present to my dear Eliza.'

People certainly sent each other food at Christmas – principally turkeys and other game. In December 1819 Soane received a turkey and a hare on the 17th, a turkey and 2 fowls from Mr Burton on the 21st, and on the 23rd turkeys from Mr Grundy, Mr Davis, Mr Dillingham and Mr Oxden and a turkey, 2 pheasants and a hare from Mr Martyr. Mr Dillingham was a client and friend and Mr Martyr and Mr Grundy were craftsmen whom Soane regularly employed. In November 1814 he recieved a rather sad letter from a client, the Revd John Monins of Ringwould in Kent who writes to say that his two eldest children have just died from scarlet fever. His wife is expecting a baby very shortly so they will be at Canterbury for some months. He is sending a turkey by that night's Deal coach rather than wait until Christmas – as they are going to be away he fears they may be stolen. Clearly turkeys were a valuable commodity. Soane in turn sent birds to other people. In 1815, for instance, he sent turkeys to Mrs Smith, Mr Hofland and Mr Shee, hams to Mr Phillips and Mr Richard Smith and a pheasant to Mrs Smith. On 1st January he sent cake to three ladies of his aquaintance: Mrs Neave, Mrs Foxhall and Mrs Higham.

Then as now, turkey featured prominently on the menu, together with fowls, pheasants, hams and hares, as we have seen, and on 18 December 1832 there is a staggering entry in the Cook's Book for a 25lb Round Beef. Sadly there are no entries in Soane's diary at this point, so we do not know what company he was entertaining to require so much beef. Oysters are a traditional start to Christmas dinner, a custom still adhered to in the South of France, and certainly 6d worth were purchased by the Cook on 24 December 1819, as on several other occasions that month. Mrs Soane's cookery book, *The London Art of Cookery* by John Farley, even features a recipe for oyster sauce for turkey!

Quantities of suet appear in the Soanes' Cook's account books at this time of year, for the making of plum pudding (plums being dried plums, that is to say prunes). The pudding would have been eaten as part of one of the first two savoury courses, as an accompaniment to meat, rather than as a dessert as now. Christmas, or minced pies were also much consumed for the two or three days around Christmas. Minced meat actually included meat – once again the mixture of sweet and savoury. One contemporary recipe even suggests the substitution of tripe on occasion. Every year for which we have housekeeping bills on a date somewhere in the second two weeks of December what is clearly a Christmas order is purchased from John Jordan, Wholesale Tea-Dealer and Grocer at the

Bill for Christmas provisions, 1820.

Cocoa Tree, 302 High Holborn – in 1818 for instance 3lb currants, 3lb raisins, 2 oz peel, 1 oz nutmeg, ¼ oz mace, and in 1822 3lb currants, 1lb [Blooms], 2lb valentias, 2lb moist sugar, ¼ ginger, ¼ mixed peel. 1 oz cloves, ½ oz spice and ½ oz mace.

Wine was of course drunk, and this clearly often included champagne as on Christmas Day 1820 Soane records: 'Christmas Day!!! Mr and Mrs Conduitt dined here. No Champaign!' The servants were not forgotten, for punch and porter were purchased for them; usually 12/- worth.

The 6th of January, or Twelfth Night, was also an occasion for celebration. It has rather lost its significance in Britain today, except as a time for the taking down of decorations, but in Soane's lifetime it was still an important day with its own rituals, which included a cake and elaborate games rather like our charades. The cakes had become increasingly elaborate, with sugar frosting and gilded paper trimmings and confectioners' shops vied with each other in their displays. Traditionally they were baked to include a bean and a pea, so that those who received the slices containing them should be designated the king and queen of the night's festivities. The tradition continues in France today, and just after Christmas the supermarkets are full of 'Galettes des Rois'.

The Soanes usually treated their servants in some way; on 6 Janaury 1821 Soane records: 'Treated the servants with cake etc. 12/-', and on 6 Janaury 1817 Soane's Butler paid £0.7.0 for a twelfth cake.

Christmas, or rather the day after Christmas, was also the time for the giving of Christmas Boxes. Every year Soane gave 10/6 to the Beadle and Watchmen of Lincoln's Inn Fields, 1/- to the Turncock, 2/6 to the General Postman and 2/6 to the Twopenny Postman. It was left to the Cook to give 1/- each to the Dustman, the Sweep and the Newspaper Boy. When Soane went to Chertsey on 26 December 1815 he gave the Coachman 3/- for his Christmas dinner. In 1806 on 30 December he records: 'At the Bank, gave parlour door keepers as usual £2.2.0 and [Sh]ackell at the gate £0.7.0.' Similarly on 31 December 1828 when he dined with the Royal Academy he gave the Servants 5/-.

15. I am indebted to C Anne Wilson *Food and Drink in Great Britain*, Constable, 1973, for this description.

16. See Plate 1 in Alison Kelly *Mrs Coade's Stone*, The Self Publishing Association Ltd, 1990.

17. From a manuscript entitled 'Advice and instructions given by Mr Ruinart de Brimont to his sons Thierry and Edmond concerning the commerce of the wines of Champagne' quoted in Patrick de Gmeline *Ruinart the oldest producer of champagne from 1729 until today*, Stock, 1996.

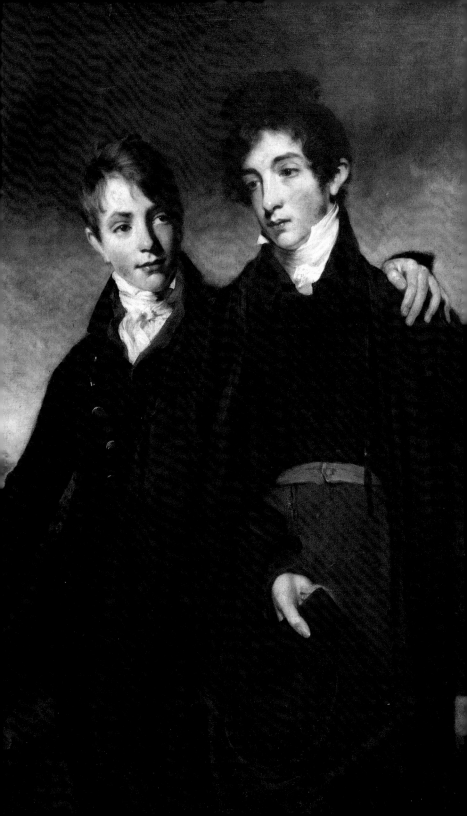

6

THE CHILDREN

As we have seen, by the time the family moved to Lincoln's Inn Fields John and George were eight and five years old respectively (see overleaf). Two other sons had been born to the couple, but sadly neither had survived. A son called George born in December 1787 had lived for only six months, and their last child, a boy called Henry, born in October 1790, had died of whooping cough in 1791.

It is clear from an entry in the diary of Joseph Farington that Mrs Soane would have loved to have had at least one daughter. On 14 November 1795 he records: 'Soanes I dined at . . . Mrs Soane told me that having only two Sons of her own & no girls, she wd. willingly have taken a little girl of Mrs Playfair's [the architect, James Playfair, who died in 1794 leaving his family in straitened circumstances] to educate; that she had hinted as far as she could such a proposal, but Mrs Playfair expressed herself in such a way that she cd. not proceed.'

We know virtually nothing of the early years of both boys' lives, save that John spent his first two years with a foster nurse, Elizabeth Walker, and that his brother, too, was sent to a wet nurse as Mrs Soane was very weak after his birth. George's wet nurse was the wife of a journeyman bricklayer by the name of Leake, who had a son of the same age who died. Mrs Soane having discovered that the woman was a drunkard, attempted to remove George from her care, having engaged another nurse to care for him. Mrs Leake, however, refused adamantly to give him up, and in the end had to be summoned to appear at the Court of Conscience in Vine Street, Piccadilly, with the child and all his clothes, where she was forced to surrender him to Mrs Soane.

By 1794 both boys had graduated from the 'petticoats' or dresses that boys wore until they were four or five years old, and John had been away at school, an establishment run by a Mr Green, since May of the previous year. Four years later in 1798 (the year in which they are depicted by Joseph Gandy in the view of the family at breakfast, page 53) they were both at a school run by a Mr Wicks. Soane evidently had no very high opinion of the education they were receiving there as he recorded in his Account Journal on 29 January 1798: 'Paid Mr Wicks for <u>not</u> teaching the two boys ½ year £39.17.0', and six months later: 'Paid Mr Wicks for keeping the children in ignorance.' In January of the following year they were both enrolled in a school at 5 Queen Square, Moorfields, run by the Revd Charles Applebee. Here they stayed for nearly four years until the delicate state of John's health, (it was becoming obvious that he suffered from a weak chest), rendered

Portrait of John and George by William Owen, 1804. John, who has the darker hair, is wearing his Cambridge University gown.

Portrait of John Soane junior aged 12, by John Downman, 1798.

a move to the balmier air of the seaside advisable, and they were both sent, in September 1802, to a school in Margate, where the family had for some years spent their summer holidays, run by the Revd William Chapman.

When not away at school, the two boys did not spend all their time at Lincoln's Inn Fields, a London town house with no garden not being the easiest place to amuse two lively and growing boys. From 1800, as we have seen, there was their house at Ealing to visit, with all the freedom of its extensive grounds and the surrounding countryside. It is possibly at Pitzhanger that Mrs Soane and the two boys are depicted in the portrait by Antonio Van Assen of around this date (see page 8). There several dogs were kept – Dido, Sheba, Lion and Toby are names that occur at different times in Soane's diaries – and no doubt the two boys accompanied their father on fishing expeditions.

Besides their time at Pitzhanger and their annual summer holidays by the seaside (see Chapter 7), John and George spent a lot of their time in the countryside at Chertsey, the small Surrey town where Soane's brother William and his aged mother lived, and where the family had a number of friends. Here they stayed with Mr Smith, the Surgeon, and his wife (for further details of life at Chertsey see Chapter 7). On 8 January 1797 Mrs Soane wrote to her Chertsey friend Sally Smith: 'I propose being at Chertsey next Thursday, but you know I am very uncertain so it may be Saturday, yet I wish much to get rid of the Boys for they really worry me beyond bearing and I have been quite a Prisoner ever since their arrival, perhaps you'll say this is my own fault, and in some measure

Portrait of George Soane aged 13, by George Dance the Younger, 1802.

it really is, but such are my feelings, that I can not bear the Idea of my Children being the companions of Servants.'

With the exception of a child's high chair, none of the boys' childhood possessions or toys have survived. We know, however, of some at least of them from notes in their father's diary and accounts. The four-year-old John had 'An Organ' bought for him in 1790, and later there are records of the purchase of 'a Sword for John', 'tools for George', 'a screwdriver for John', knives and a corkscrew. No doubt they would both have played with the spinning tops and hoops with which most small boys are depicted in Regency engravings, and at school at various bat and ball games. The presents which Soane purchased in later years for his grandson, John, son of John junior (see below) also give us further clues to toys they probably enjoyed; there are references to the purchase of a rocking horse, a Romance, 'a beautiful new game . . . that persons of any age . . . may like to play . . . with him' and 'a dissected map of English History' – a jigsaw as we would call it.

When the children were in London there were family outings to be enjoyed. In May 1793 Soane records taking the seven-year-old John to Mount Pleasant and White Conduit House, the Islington tea-garden, for a treat and from the age of five he was certainly taken to the Royal Academy. The whole family went to the theatre on occasion, too. As they grew older Soane records taking his sons to various coffee houses. John in particular seems to have accompanied his father on occasional business trips, to Holwood, William Pitt's house, for instance in 1797

and to Lord Hawkesbury's at Combe in 1802. The boys were expected to make themselves useful too: one entry in Soane's diary records; 'Pd. Geo. for repg. a fishing rod £0.2.0' and another: 'This day George finished the catalogue of the Books by throwg. the Ink on the floor & breaking the Inkstand to pieces!'

In September 1804 the eighteen-year-old John went up to Cambridge University, to Trinity College, and it is in his cap and gown that we see him depicted in the portrait of this year of the two boys by William Owen (see page 82). His anxious mother had spent some time preparing his clothes for going away and packing his trunk, and records in her diary for 8 and 9 September: 'Went in Cambridge coach with John' and: 'At Cam. all day settling John.' His younger brother George joined him at the university in March 1806, initially at the same college, although the following year, for reasons which are not entirely clear, they both transferred at their own request to the smaller Pembroke Hall.

John's health now began to give serious cause for concern, and he was forced to spend some time in Margate with his mother in 1807, never in fact returning to Cambridge to complete his degree. Whilst there he evidently renewed his acquaintance with Laura, the daughter of his old schoolmaster William Chapman, and the two became secretly engaged for a brief period when he returned to London in the autumn, before Soane discovered the situation and put a stop to it. George continued at Cambridge for a further two years, and it is evident that the habit of incurring heavy debts that became such a scourge in his later life, began at this point.

This is not the place for a detailed biography of the two boys, but the reader will, no doubt, wish to know the facts in outline. Soane cherished a wish that his elder son, if not both boys, should follow him in his career as an architect. John showed some talent in this direction, and after a few months working in Soane's office he was sent as a pupil to Joseph Gandy, who had set up in practice in Liverpool. His time there was, however, interrupted by several severe bouts of illness, and it became clear by 1810 that he lacked the physical robustness and perhaps the application to succeed. His younger brother was described by Soane in a letter to an old friend in that year as 'smitten with a passion for dramatic writing'. Having briefly tried both the law and medicine, and having rejected the navy, army and church as professions, writing was what George turned to, and with some measure of critical, if not financial success, though much to the distress of his parents.

John was married in June 1811, to a Maria Preston of Sewardstone in Essex, whom he had met whilst on holiday in Margate. Soane was not particularly pleased about the match, and even less so with that of George who got married the following month to Agnes, the daughter of James Boaden, a theatrical journalist.

John and Maria divided their time between Soane's house at Chelsea Hospital and the sea air of Brighton, later travelling on the Continent between August 1818 and mid-1820 in an attempt to alleviate John's worsening consumption. Whilst they were in Naples in January 1820 their third child, Harriet, was born, a sister for Elizabeth, born in 1813 and Maria born in 1815. Their last child, a son, John, was born in 1823 after their return to England. Only a few months after the birth of his last child, John died in Brighton at the early age of thirty-eight. After his death his family continued to live at Soane's house in Chelsea. Relations with his daughter-in-law, Maria, were not particularly warm, but Soane was evidently

Portrait of Harriet Soane, John Soane junior's third daughter, drawn in Rome by Seymour Stocker Kirkup, May 1820, when she was five months old.

very fond of his grandchildren, sending them presents of dresses, work-baskets, nosegays and toys, and, as they got older, copies of his books when they were published.

A charming letter from his grand-daughter Elizabeth survives, dated 24 December 1829:

'*My dearest Grandpapa*

Maria and I hope you will do us the favor to accept the enclosed purses with every affectionate wish of the season and we are most anxious to hear that this very severe weather does not affect your health.

You must forgive me for telling you that you are mistaken in my age as I shall be 18 years of age in March instead of 17, and Mama intends introducing me this year. I am sorry to say John's cough is not quite gone, but he is very patient and consents to remain in the house this cold weather. We endeavour to amuse him in the evening by teaching him to dance. Mama presents her compliments and my brother and sisters unite with me in love.

And believe me, Dear Grand-papa

Ever your affectionate Grandchild

Elizabeth Soane.'

A photograph of the purses, which were found still wrapped in the letter in 1989, can be seen on page 79. They had evidently been worked by the sisters themselves, netting being a common occupation for young women, and one frequently referred to in the contemporary novels of Jane Austen. Charles Bingley, for instance, in *Pride and Prejudice* refers thus to the accomplishments of young ladies: 'They all paint tables, cover screens and net purses. . .' Soane's son John can be seen wearing just such a purse tucked into the waistband of his trousers in the 1804 portrait by William Owen which hangs in the South Drawing Room (see page 82). Three years after the date of this letter Elizabeth, or Bessy as she

Architectural drawing by John Soane junior's son John, executed on 1st July 1836 when he was thirteen years old.

was known in the family, incurred her grandfather's severe displeasure by eloping to Gretna Green with a Captain Frederick Chamier, a Captain in the Royal Navy, whom she had met while in Paris with her mother. Her grandfather had suggested that they delay getting married for a few months until she had attained the age of twenty-one. They had but one child, Eliza Maria, born in January 1833. Her sisters also married but both died without issue. Soane had rested his hopes on his grandson John for continuing the profession of architecture within the family, paying for his schooling and dedicating his *Memoirs of the Professional Life of an Architect* of 1836 to him. John married in 1844 a girl called Marie Borrer whom he had met in Brighton, where he had a house left to him by his father. He was only to survive four years, however, dying abroad in Madeira in January 1848 at the age of twenty-four. Had he perhaps inherited his father's tuberculosis? The couple had no children. His grandfather had made provision in his Will for him to request permission of the Trustees to live in the Museum on attaining the age of twenty-five, and negotiations were in train when news of his death reached London.

George got into serious debt soon after his marriage to Agnes, no sooner being rescued by his parents than the whole cycle began all over again, much to his mother's distress. At the end of 1814 he ended up going into debtors' prison for a few weeks. Released in January 1815, a few months later in September he wrote a scurrilous attack on his father's architecture in *The Champion* newspaper. Although it did not bear his name it took Soane little time to establish his authorship. Mrs Soane, who was unwell at the time, was dreadfully upset and said, as later recorded by her sorrowing husband, 'George has given me my death blow, I shall never hold up my head again.' On her death barely two months later Soane vowed to cut George out of his life for causing 'the death of all that was dear' to him, although mindful of George's wife and family he was persuaded to continue to pay them a small allowance. George and Agnes had four children; Caroline, born in 1811 who sadly died aged 16 on 29 November 1827, Frederick born 1815, Clara Agnes born 1817 and Rosa Maria born in 1819. Soane paid for the education of Frederick, as he was also to do for that of his cousin John, and

evidently cherished the notion of interesting him in architecture as he also paid for drawing lessons. Frederick proved, however, to be a less than apt or willing pupil, and relations were eventually broken off with his grandfather, although he continued to receive an allowance. Relations with George worsened in 1832 when Soane discovered the existence of a second son, George Manfred, born in 1824, who was in fact George's son by Maria Boaden, his wife Agnes' sister, who had been living with them for some time.

Nothing further is known of the illegitimate son, George Manfred. Rosa Maria and Clara went on to marry, Rosa Maria having four children, but Frederick died unmarried. George himself lived until 1860, dying at the age of seventy-one, with a total of eighteen works to his name. Besides his romantic novels, which included such titles as *The Eve of San Marco* and *The Peasant of Lucerne*, he made a number of translations from the German, including one of part of Goethe's *Faust* which was praised by Goethe himself.

7
HOLIDAYS

Chertsey

Soane travelled much throughout the country in the course of his work, meeting clients and inspecting the progress of works. Mrs Soane seems rarely to have accompanied him, though she became firm friends with the Duchess of Bridport and went with her husband to stay at Cricket in Somerset on several occasions.

Instead she preferred to escape the heat of the summer and the fogs of a London winter by spending time at Chertsey, the small Surrey market town on the borders of Middlesex where the Soanes had a number of friends and relatives. Soane's aged mother Martha lived there until her death in 1800, as did his elder brother William, and family friends of Mrs Soane, the Smiths – Mr Smith the surgeon and his wife, their son, Richard, who was an apothecary and their daughters Sarah,

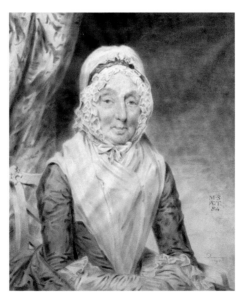

LEFT Detail from English School: *Garner's (The Marine Library) High Street, Margate*, c.1820. On the left can be seen the bathing house 'cubicles'.
Garner's Library is in the middle distance.
ABOVE Portrait of Soane's mother, Martha, at the age of eighty-four.
Painted by John Downman, 1798.

A view near Chertsey, Surrey by William Daniell, n.d. A number of people can be seen fishing from the river bank.

or Sally, who was Mrs Soane's particular friend, Sophia and Fanny who was an invalid. Here she would come for several weeks at a time, contributing to her board and lodging. The children, John and George, spent much time here in their school holidays, even when their parents were in London.

Sometimes Mrs Soane took a public coach from Hampton or Hounslow, having been conveyed thither by their own Coachman. At other times, when Soane did not need it, she took their carriage with her to use for outings. These included trips to the races at Epsom, and trips such as the one which on 26 June 1812 she wrote to Soane to complain had been postponed because of the rain: a journey to 'Weighbridge [Weybridge] to see the grotto'. In Chertsey itself she showed an interest in the excavations at the Abbey; Soane recorded in his diary for 26 June 1814: 'Mrs S. went to Chertsey to see ruins dug up.'

There was much opportunity at Chertsey to indulge in one of her favourite pastimes – playing at cards. In a letter of June 1815 she writes to her husband that she is just going to play a Rubber with 'the old Chamberlens lady', the wife of Timothy Tyrrell, a patron of Soane's. Likewise in 1804 she writes to warn her friends that they will have to give her credit as she has lost all her sixpences. Small dances were another pastime.

While she was staying in Chertsey Soane would try to join her for the occasional weekend. These visits were the occasion for special meals. In anticipation of such a visit in August 1812 Mrs Soane wrote: 'Mrs Smith has provided a ham of her own curing and a bottle of very good old port which has never been in a tavern.' In June of 1815 Soane had evidently sent down some venison, which, she writes, she proposes having dressed at the Swan Inn (kept by the parents of William and Thomas Daniell, Royal Academicians). She has, she says, invited Mr and Mrs C[larke] to dine with them on Saturday at Mrs Smith's, and asks him if he would bring 2 or 3 bottles of port and the same of sherry.

Soane's chief delight in going to Chertsey was the opportunity it afforded him of indulging in his favourite pastime of fishing. In June 1815 Mrs Soane writes to say how happy they are to hear that he proposes being with them on Friday or Saturday morning. Mr Clarke has provided pots, men etc. for dragging the pond: the other day an immense large 'Jack' [a pike] was seen sporting about, so she expects he will be much gratified. Miss S[mith], she continues, has prepared for his angling on Sunday, but from the specimen of last time she thinks he had better bring his own tackle.

After Mrs Soane's death Soane continued to make similar visits to Chertsey, bringing supplies of food and drink with him, and seizing the opportunity of taking a boat out on the Abbey River.

MARGATE

Besides these visits to Chertsey, Mrs Soane also had a summer holiday. By far and away her preferred destination was Margate, the most fashionable of the Kent seaside resorts. Here she would repair with the boys, a man and maidservant, Fanny the dog and usually a female friend for about six weeks in late August or September, the timing varying a little depending on how quickly the resort had filled up that year.

Armed with the £50 which Soane always gave her for her expenses before setting off, they would travel down in the carriage, the journey taking the best part of two days. Their trunks had to go by sea, on one of the sailing ships or hoys that plied between London and Margate. As they got older one or both of the boys would often travel by sea too. Usually this only took about eight hours, but occasionally contrary winds would delay the journey, and on 21 August 1809 Mrs Soane reported in a letter home that poor George had been all night aboard.

On arrival the first task was to find somewhere to stay. It was not necessary to book accommodation in advance as the circulating libraries, of which there were three in Margate, acted as accommodation agencies. Rooms in boarding houses

Bill for a portmanteau, or trunk, purchased by Soane before his 1814 trip to Paris (see page 96).

were available, but by far the preferred option, and Mrs Soane was no exception in this, were rooms in a lodging house. *The Margate and Ramsgate Guide in Letters to a Friend* of 1797 quotes a rate of 1 guinea per week for a parlour, chamber and the use of a kitchen in lodgings near to the sea. On 21 August 1809 Mrs Soane wrote to her husband to tell him that they had found a comfortable and splendid house with plenty of room at 36 Hawley Square. She was not always so lucky however, as she wrote from Brighton on 22 April 1811 complaining that they had to pay 2½ guineas per week and 4s each for the use of the servants (she had clearly travelled without hers on this occasion). She continued that she did not like what she had seen of the company in the house 'who appear proud and insolent'. By far the worst constraint however appears to have been that Fanny's presence was barely tolerated, and that she had to go out on a lead following an order promulagated after a scare about mad dogs. She finished by saying that she was determined to take a lodging, and asked Soane to spare the Cook and send her down.

A number of friends from London were usually in Margate or neighbouring Ramsgate at the same time, so there were visits to be made and dinner invitations to be exchanged. In August 1803 John Braham and Nancy Storace the singers were in Margate. Soane had sent his wife a gift of venison and she writes to describe a large dinner party, twenty-one of them without the boys, to which the singers were invited. Not having a cook or the convenience for dressing such a dinner she reports that she sent the meat to Kidmans [Hotel] and they had the whole there. After the meal Nancy evidently sang, for Mrs Soane reports that Soane's friend Mr R Bosanquet was too ill to come but came to coffee and heard the singing. She further reports that he has introduced them to Captain and Mrs Bynn of the Texel, where they are engaged to dine and attend a ball.

The Assembly Rooms in Margate were another great source of evening entertainment. In July 1796 Mrs Soane wrote to her friend Sally Smith, who she hoped would be allowed to accompany her to Margate that year, urging her to come as 'we shall have such merry doings there'. In her next letter she asks her to bring her hat (which she had evidently left behind in Chertsey) as she intends 'to shine in the Rooms'. In 1797 the subscription to the Assembly Rooms was ½ a guinea for the season. There were balls twice a week, card playing, tea and coffee drinking and a band at lunchtime.

On 26 August 1804 Joseph Farington describes in his diary a visit to the Assembly Room in the evening 'where there was a Promenade and a very large Company attended. One Shilling is paid by each person for admittance. – I spoke to Mrs Wheatley who was with Mrs Soane.' In fact on this occasion Mrs Soane and her friend were staying at Ramsgate, as Farington recorded a few days earlier on 17 August. He further records the details of an evening spent at the Ramsgate Assembly Room on 11 August 1804 'where Madame Bianchi sang several songs to a Piano forte & Meyer played on the harp. At ½ past 9 the music was over. 7s 6d was paid by each person for admittance. A Ball then commenced. At Eleven we came away. There was much Company.'

Mrs Soane's accounts of the social life of Margate are supplemented by a small group of letters written to John Soane junior in the autumn of 1807 by Laura Chapman, the daughter of his old schoolmaster, to whom he was secretly engaged for a short period in that year. She describes balls in the Assembly Rooms and laments that they will be in want of beaux unless a regiment soon

appears: two or three Companies of the 32nd are there but they are under marching orders for Portsmouth.

The circulating libraries also offered evening entertainment, including concerts, and Mrs Soane records that Nancy Storace gave a benefit on 27 August 1803. There was also a permanent theatre, the Theatre Royal, erected in 1787. Both Nancy Jordan and Mrs Siddons played there, and Laura Chapman's letters describe several performances by Master Betty, a popular actor, several of whose performances the Soanes attended in London.

During the daytime there were the pleasures of strolling around – Laura Chapman mentions walking on the Fort – or of visiting nearby places such as Ramsgate. Donkey riding was one of the entertainments available, and one imagines the two boys must have indulged in this pastime. Certainly on a later holiday in Brighton in May 1811 Mrs Soane mentions in a letter home that John has just returned from a ride, and goes on to complain that each one costs 7 shillings, and donkeys only half as much. There were also the pleasures of the circulating library for the reading of newspapers and magazines, the reading and borrowing of books, meeting people and exchanging gossip and purchasing stationery, fancy goods, trinkets and Tunbridge ware as souvenirs. The shops attached to circulating libraries ran frequent raffles of their goods and on 8 September 1809 Mrs Soane wrote to her husband that the boys had just won nearly 5 guineas for 3 shillings; the master of the shop only being willing to give goods rather than money they were having great fun choosing what to take.

When the pressure of business would allow Soane would join his family for a few days by the sea. On 25 August 1796 he records in his diary that he left London in the morning Diligence with Mr Hatton, leaving again at 6.00 am on 29 August and getting home about 9.00 in the evening. Whilst there he records visits to Ramsgate and to Kingsgate, where a party of them dined: Mr T Dance, Dr West, Miss West, Mrs Thomas and Miss Smith, Mrs Soane's young friend

A view of Margate with the Bathing Place from a drawing by J Smith, published in 1786.

from Chertsey. In September 1806 he records trips to Minster and to Pegwell Bay and a trip to Canterbury with his son John. There are records, too, of dining with numerous friends, often including Braham and Storace.

Last, but by no means least in the daily round, there was sea-bathing – the very reason for the growth of the resort in the first place. The sea air, and in particular sea-bathing were held to be very beneficial to health. Margate was particularly good for bathing because of its flat sandy shore and calm sea. Bathing was done from bathing machines which were drawn into chest-deep water by a horse. The bathers descended into the water through a door at the back and down some steps, and a canvas umbrella was then let down to conceal them. Women wore flannel gowns to bathe, which they put on under their clothes in the morning. The bathing rooms at the back of the High Street through which one gained access to the machines (see page 90) were open from 6.00 am, and guidebooks advised one to get there about 7.00 am to put down one's name. One's turn apparently often did not come about until about 9.00 am when the rooms were busy, and in the meantime people assembled and conversed. The terms for using these machines, according to the Kent volume of Brayley's *Beauties of England and Wales* of 1808, were 1s 3d for a lady taking a machine with a guide, or 1s for two or more ladies. For gentleman the rates were 1s 6d or 1s 3d. Gentlemen also had the option of bathing themselves at 9d. Children cost 1s 3d or 9d for young children.

Besides sea-bathing there were warm baths. In September 1811 while staying at Ramsgate Mrs Soane reports that she intends going into the Warm Bath the following day. She asks Soane to ask their doctor, Mr Pennington, whether she should go in to the Cold Bath to 'take off that nasty little fever [she] is plagued with at times'. Evidently he had advised against it as her letter has been annotated by Soane 'must not'.

FRANCE

In September 1814, while staying at Brighton, Mrs Soane took advantage of the cessation in hostilities with France to visit Dieppe. Until the war sailing packets had been regularly plying between the south coast resorts and the Continent, and it was on one of these that Mrs Soane and her party embarked. Sadly we have very few details of her trip, save that they were absent 8 days and only went to Rouen, having been detained 3 days at Dieppe by contrary winds. Mrs Pennington, presumably the wife of their doctor, was, she reported, on the same boat, going to Paris for her health. This was to be Mrs Soane's only trip abroad during her married life, though it was evidently one she intended to repeat, as Lady Bridport wrote to Soane from Cricket on 17 May 1815 suggesting Mrs Soane might accompany him on a visit to them 'as I do not think from the present state of the Continent, she will be inclin'd to put her plan of travelling in execution, or that you would consent that she should.'

Soane, too, made two trips to France at this period. In August 1814 he spent two weeks in Paris, travelling in the company of a young architect, Redmond William Pilkington. We know little about this trip, as he did not keep a diary of it, although we do know that he carried with him a letter of recommendation to a Msr Feuchere who was requested to accompany Soane to Versailles, and that he

and Pilkington visited Malmaison, the residence of the late Empress Josephine, who had died only three months previously. Five years later in 1819 he spent the best part of a month in Paris, this time accompanied by Mr and Mrs Conduitt, and also by his pupil, Henry Parke who was to act as draughtsman. A number of the drawings he made on this trip were later worked up into large size drawings for showing at Soane's Royal Academy lectures. The diary Soane kept of the trip records days spent exploring Paris, and trips to Neuilly, Sèvres, St Cloud, Malmaison and Versailles. Much time too must have been spent in the bookshops of Paris, to judge by the surviving bills for books purchased there.

HARROGATE

After Mrs Soane's death in November 1815 Soane did not again holiday in Margate or the surrounding resorts, turning instead to Harrogate in Yorkshire, Bath, Brighton, Cheltenham and to Worthing and Hastings. His first visit to Harrogate was in July 1816 in the company of Mr and Mrs Conduitt and Mrs Hofland, besides his manservant, Joseph Beynon. Mrs Hofland must have proved a good guide as, born in Sheffield, she had lived in Harrogate for several years prior to settling in London at the end of 1811. Nevertheless, Soane prudently sought advice from friends before setting out, being advised in a letter from Samuel Thornton dated 14 June 1816 that his niece, who has just returned from Harrogate, informs him that Mrs Woodland of the Green Dragon Hotel is the best person to apply to for private lodgings as the Mistress of the Granby, the largest Inn, has not conducted it well. Mr Richardson, he continues, is an apothecary of some skill, and his name, or that of Mrs Milne's, his niece's mother, will serve as an introduction to him.

Both of the inns mentioned were in the more fashionable Upper Harrogate. Unlike the south coast resorts, the infrastructure was not such as to support

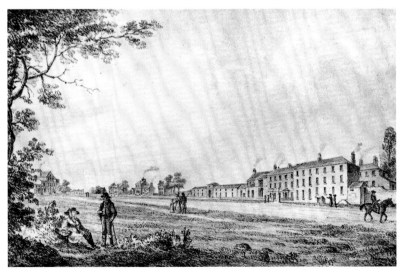

A view of High Harrogate engraved by J Stubbs in 1829. The Green Dragon Hotel is on the right.

the growth of individual lodgings. All visitors stayed in one of the many inns available. Private parlours could be rented, but all meals were taken communally, the table being presided over by the person who had been staying longest, and whose job it was to smooth over social blunders. Controversial subjects of conversation such as religion or politics were banned.

Joseph Farington, who visited Harrogate in 1801, included this description of the customs of the house in his diary entry for 30 August:

'The arrangement at Harrowgate is as follows.
Breakfast ready at 9 o Clock Dinner at abt. ½ past 4
Tea at ½ past 6 Supper at 10.

A Collection for Wine & liquors of all kinds is made daily after dinner at each table for the <u>preceding day</u>. – The Bill for other things remains till called for. [He reveals in a subsequent entry that 6s a day was charged for meals] – Fruit is brought in by different persons both at Breakfast & after Dinner in baskets, and offered to each Individual who purchases or not as He or She may be inclined. – An intercourse of civilities is kept up between the Company at the Green Dragon & the Company at the Granby. A general invitation to a Ball, to begin at ½ past 7 is sent from each House in turn. Those who go pay one Shilling on entering the room, & such <u>Gentlemen as Dance</u> pay each four shillings more. The Ladies do not pay anything in addition if they dance. These Balls do not continue long, as it is customary for the visiting Company to return to their own House <u>to Supper</u>. – about Eleven o Clock.'

The season was short in the northern spas, beginning late, in July, because of the climate. Thus they did not warrant an elaborate assembly room like those of the southern spas. The social life centered around the long rooms of the large inns where balls were regularly held. There were also shops to be visited, two circulating libraries for newspapers, books and exchange of gossip, the drinking of the waters and bathing for the improvement of health, and excursions to neighbouring beauty spots.

Mrs Hofland had published in 1812 *A Season at Harrogate in a Series of Poetical Episodes, from Benjamin Blunderhead, Esquire, to his Mother, in Derbyshire* . . . which describes, very amusingly, all these pastimes. All the excursions mentioned therein were taken by Soane's party; they went to Plumpton Rocks, to Knaresborough, to York, to Castle Howard, to Studely Park and Fountains Abbey and to Rippon Minster. Besides these outings Soane records that he drank the waters most days and partook of a warm bath on several occasions.

He returned to Harrogate the following year and on several subsequent occasions. In 1824 he still evidently favoured the Green Dragon Hotel, as a letter survives from Thomas Ripley, the proprietor, to Joseph Beynon, Soane's manservant, regretting that the parlour Soane had before is occupied, but promising to try and accommodate him. In the event this was clearly not possible as letters written to him in Harrogate that year are addressed to Hattersley's Hotel, which he describes in his diary on 11 August as being 'between upper and lower Har[rogate], an excellent House, and civil and clean people'.

Bath

The other main place to which Soane liked to repair for his health after his wife's death was Bath. In September 1826 he spent a month there, accompanied by George Wightwick, who was on this occasion acting as his amanuensis, his eyesight being too bad to work himself on the manuscript on the New Law Courts he was then preparing for publication. Wightwick later wrote a wry account of this period with Soane.[18] Soane stayed in lodgings in North Parade whilst Wightwick stayed in a boarding house, the occupants of which he describes as 'a queer assemblage of old maids and bachelors'. Bath was by this time past its fashionable best, but Soane was in any case not minded to indulge in the entertainments of the Assembly Rooms. He contented himself with drinking the waters at the King's Pump and taking carriage rides to such picturesque local spots as the Upper Bristol Road and Lansdown Hill. On a visit in September 1829 he called on William Beckford at his house in Lansdown Crescent. On this occasion he was staying in a house kept by Mrs Newman at 12 South Parade, which he described in his diary rather tersely as 'most inconvenient apartments – one, there being no proper water closet'.

18. See note 9, page 43

8

ILLNESS AND DEATH

OF THE SAD DEATHS of two of the Soanes' children as babies no more is known than the bare facts already related. Infant mortality was much greater at this date, and few families were strangers to childhood deaths.

Mrs Soane seems not to have been troubled, until the end of her life, by illness, except the inevitable headaches and colds suffered by everyone from time to time. Perhaps it was on one of these occasions that she was prescribed 'The Powders. One to be [taken] every morning in Camomile Tea', the only surviving evidence of which are scraps of torn up paper bearing this legend, found in a mahogany knife box when it was being cleaned.

In her early fifties, however, signs of more serious illness began to appear, which were not in the least aided by her worry over her youngest son and the financial difficulties in which he was frequently embroiled. The Cook later related an incident in July 1815 when after a shivering fit her mistress said to her: 'If I die, Cook, tell my youngest son he has broke my heart.' Eventually gallstones were diagnosed, and she went to Cheltenham in August 1815, in the company of her friend Sarah Smith of Chertsey, to seek a cure. Going down to see her at the beginning of September Soane found her 'very ill in bed'. But gradually under the ministrations of Dr Jenner and Dr Boisragon she improved. On 13 September Miss Smith wrote to Soane to report that the only unpleasant symptom remaining was a dryness in her mouth for which Dr Jenner had prescribed saline draughts twice a day; 'her appetite yesterday astonished me' she continued, 'she thinks she could eat a pint of jelly at a time so we have got a fresh supply'. On the 25 September Mrs Soane herself wrote to her husband, saying that apart from some pain the day before she was feeling better than for months. That morning she had seen Dr Boisragon, who 'says <u>word</u> for <u>word</u> what Mr Pennington says' [their family doctor, whom Soane had evidently consulted]. Dr Boisragon had, she continued, ordered a small pill every other night, [drinking] the waters every morning and above all the double horse [presumably some sort of mechanical horse on which the patient sat]. He thought, she said, that there were more stones to pass, and although assuring her the complaint was not dangerous, said if she did not get rid of it now it might return in a few months with double force. If she did, however, she would have better health than she has had for many years. George's articles in *The Champion*, which Soane showed her on 13 October were, however, a severe blow, and not likely to aid a swift recovery. Nevertheless, she returned to London

Perspective of the Soane family tomb under construction, 1816.

on 28 October, and was well enough, from the evidence of her diary, to take short walks and visit her old friends Mrs Foxhall and Mrs Kinderley. Indeed, Soane records, retrospectively, of 20 November 1815: 'Mrs S. was in the evening at Mrs Kinderley's – for the last time – in great spirits and as usual the delight of all the party!' On 21 November, however, he records in his diary: 'Mrs S. seized with spasm immediately after breakfast – I staid with her until quite recovered & then went to Chelsea, & ret. found Mrs S. had relapsed & ill in bed. Mrs. S desired Mrs Shee might act for her at dinner.' The next day he continues: 'Went for Dr P[emberton] ½ before 9 retd. with him – no hope & 20 m. past 1 my dear wife expired, I was in the room about 3 min before.' Her obituary in the *Gentleman's Magazine* for December 1815 goes into further details: '. . . A larger gall-stone than common, in passing from the gall-bladder through the biliary duct, appears to have occasioned a bursting of the gall-bladder, when a mortification and almost immediate death ensued', adding that 'This case is of rare occurrence.'

Sarah Smith of Chertsey, who had been alerted by Joseph Beynon, Soane's Butler, arriving in a post-chaise to fetch her to her friend's bedside, but who had arrived too late to see her alive, kept a rough diary of events in the days immediately following Mrs Soane's death. She records the names of the friends who on that first day sat with Soane, who was, understandably in a very distressed state. In the evening Mr Pennington gave Soane a draught 'to compose him' and he went to bed at midnight, leaving Sarah Smith sitting up with Anne, one of the Housemaids, to await the arrival of John Soane junior, who arrived from Brighton at 1.30 in the morning. Over the next few days she records the visits of several of Mrs Soane's friends who came to the house to pay their last respects. On the evening of Friday the 24th the coffin, 'the last sad receptacle', was brought into the house and the following Tuesday she records that 'the sad remains [were] closed between 2 & 3 o Clock, Mr Burton [presumably the undertaker] present'. On Thursday the 30th the coffin was moved to the Library where it was covered with a pall and feathers (these were usually black ostrich feathers). Wax candles were burnt and a servant sat up all night in the room. The funeral took place the following day at 10.00 am and she was buried in the burial ground of St Giles-in-the-Fields at St Pancras (now St Pancras Gardens), where Soane later designed and erected her tomb. 'Melancholy day indeed!' he recorded, 'The burial of all that is dear to me in the this world, and all I wished to live for.' Mourning clothes were ordered, not only for Soane himself but for his servants, and money given to various family and friends for mourning rings, as was the custom.

Another member of the family whose health should not be forgotten is Fanny, Mrs Soane's lap-dog. She had always been much pampered, and there are references to the purchase of biscuits for her, and of ticking and flannel material for her bedding. By the time her mistress died in 1815 she was about twelve years old, no mean age for a dog, and in fact she outlived her by five years. Towards the end of her life she was evidently ailing, and the household accounts include a number of bills from a Mr William Youatt, a vet who was called in to attend her. He was in fact one of the first in the country to practice as a small animal vet. In December 1818 he records 'Examining terrier bitch and cutting her nails' and during the following year he had to administer injections and aperient balls. In June and September 1820 she endured operations, but died later in the year

Bill from William Youatt, veterinary surgeon, for treating Fanny, 1820.

on Christmas Day, as Soane recorded in his diary: 'My dear little Fanny died this evening at 12 o'clock – faithful animal farewell!' Two days later he recorded: 'Fanny buried in a Lead Coffin in the morning at 7 o'clock in the stone monument erected for her in the front Court Yard . . . Alas poor Fanny! Faithful, affectionate, disinterested friend, long, very long will thou live in my recollection – Farewell!' Later, when the extension behind No.14 Lincoln's Inn Fields had been built in 1824, Soane transferred the little lead casket containing her remains to the tomb in the Monk's Yard which can still be seen today and which bears the inscription 'Alas Poor Fanny!'

The sad progress of John Soane junior's illness has already been related (see page 88), together with the attempts to alleviate it with sojourns by the sea and in Europe. Soane was informed of his death in Brighton in the early hours of 21 October 1823 by a letter that reached him later that same day, and recorded in his diary: 'Poor John changed in the Morng. at 5 and died at 8!! Alas my Dear Boy, I recd. the fatal news in a letter from Mrs Rawston late in the Eveng.' His funeral was arranged by Mr Robins, a long-standing client of Soane's. The bill for this, which is preserved with Soane's other papers, is a very detailed one. In keeping with the custom of the time John's body was wrapped in a shroud and placed in an inside coffin of elm quilted with cambric. Round this was an outer coffin of cast lead, and outside that an outer case covered in black velvet studded with a double row of brass nails, and with four pairs of richly chased handles.[19] The hearse, pulled by six horses wearing plumes of black ostrich feathers, travelled up from Brighton to Croydon on the 28th of October. The coffin was covered with a velvet pall for the journey and plumes of black ostrich feathers were placed on the lid. Four pages with truncheons accompanied it on the journey. The following day, in Soane's words: 'The hearse left Croydon & got to Blackfriars Road by 9 – at 11 the procession set out for Pancras – where the remains were deposited by the side of his dear Mother!' Two coaches with four horses each, accompanied by four pages with wands took the mourners to the burial ground, each with a fringed black velvet covering and with plumes of black ostrich feathers for the horses. Crape scarves, bands and black silk gloves were provided for the mourners, and silk bands and grey beaver gloves for the two Clerks, the Sexton, the grave-digger and the bricklayer, who also received gratuities. The porters, pages, feathermen

and coachmen all wore black silk hat bands and grey beaver gloves. Similar items were provided for various people in Brighton: silk scarves, bands and gloves for the Reverend Mr Champney and two other clergymen and for the physician and two apothecaries. John and Maria's Housekeeper was given a silk scarf and hood and a pair of black silk gloves, the Butler a silk scarf, band and gloves, and the three maidservants black silk gloves. Also included in the bill is a hatchment: the family arms in a black and gold frame on black cloth stretched over wood. This would have been affixed to the outside of the house at Brighton, and may well also have accompanied the coffin to London. The following month John's widow, Maria, sent Soane a lock of his hair to be put in a ring or a brooch, apologising for it being so short, and explaining that it had had to be kept very short in the last months of his life.

Unlike his wife, Soane suffered more from various illnesses during his lifetime, though he lived to a much greater age. As early as 1795 Joseph Farington records in his diary that: 'Soane is very subject to complaints in his bowels and was but indifferent today [Farington was at Lincoln's Inn Fields for dinner] having been very ill two days ago & not yet recovered. In conversation with Mrs Soane as well as from himself I learnt that over exertion in his business frequently produces it. They have been married upwards of Eleven years and Mrs Soane said He had seldom been free from some complaint of the kind for two months together.' The affliction clearly continued for the rest of his life as there are periodic mentions of problems in his diary such as that of 22 Feb 1828 when he records: 'Duke of Clarence instal. as Grand Master of the Prince of Wales Lodge, sent an excuse from indisposition, caught cold yesterday which produced indisp. in the Bowles.' The taking of Warm Baths are recorded periodically, as are visits to such places as Harrogate and Bath to drink the waters (see Chapter 7), the drinking of mineral spa waters being held to be particularly good for the digestion. Besides the pills and draughts of conventional medicine recorded in the surviving bills of the family doctor and friend, Richard Rainey Pennington, and in letters of advice from other medical advisers, Soane was evidently quick to try any other remedy suggested; the purchase of tincture of rhubarb is recorded and preparations concocted of figs and cassiar. Likewise on 5 June 1816 he records in his diary: 'Mr Remnant, Druggist, 94 Smithfield Bar, to ask for Castor Oil drawn in England from the seed – recommended by Mr Smith, Chertsey.'

Gout was another complaint which dogged Soane for most of his life. The first mention in his diary comes in October 1801 when he records being confined to his bedroom with it for two weeks. Likewise on 12 February 1808 he records: 'Came down ill with the gout in both feet, went up stairs in the afternoon & continued there until 1st March', adding on 18 March '. . . first going out'. Similar entries follow at intervals.

A drawing of Soane lecturing at the Royal Academy in c.1812 by Thomas Cooney shows that by this date (he was now in his late fifties) he was wearing spectacles. By 1815 he is complaining increasingly of weak eyes and on occasion 'too bad to read'. The problem gradually got worse at intervals over the next few years and in December 1825 he had an operation to remove a cataract. The inability to read and write properly for a time after this depressed his spirits considerably, despite the kind attentions of various friends in coming in to read to him from the newspapers and from favourite books. He made a good recovery, but from that

point onwards weak eyes were a problem and the numerous surviving opticians' bills testify to the desperate search for just the right pair or combination of pairs of spectacles. As with his bowel complaint, other remedies were tried too, and he records one such in his diary in June 1834: 'Lotion for the eyes, Pint of Cold spring Water, Tablespoonful of White Wine Vinegar, Tablespoonful of cognac brandy, applied with a sponge.'

His operation for the removal of the cataract was not the first he had undergone, for in March 1814 he was operated on by the well-known surgeon Sir Astley Cooper, for the removal of a fistula. The operation cost £100, and in writing to acknowledge the payment the surgeon enthused 'You bore your operation so well that, next to Buonaparte, I consider You as the greatest hero of modern times.'

At the last it was none of these ailments that carried Soane off, but a chill caught descending the staircase at night. He died on 20 January 1837 at the grand old age of eighty-four. His obituary in the *Sunday Times* of 29 January 1837 describes the events leading up to his death thus: 'In May last year he had a very severe attack of erysipelas [a febrile disease accompanied by inflammation of the skin] from which it was not expected that he could recover; yet the uncommon vigour of his constitution not only brought him round, but for some months afterwards, and until within a few days of his death, his health, strength and attention to business, were nearly equal to what they had been ten years previously . . . The bad unwholesome weather of the present month did not at first affect him; he might perhaps owe his preservation, for a long period, to the comfortable temperature produced in his lower rooms by a warming apparatus, we believe, that of Perkins. His bed-room, at the upper part of the house, and top of a stone staircase, was not equally well provided. Having to leave his room and go into another on the staircase late at night, he was caught by the prevailing malady [the article had already referred at the beginning to a 'prevailing epidemic' that had caused many deaths; perhaps this was influenza]. For a few days he had it but slightly. On Thursday week he had an epileptic fit; and on Friday, at half-past three o'clock, was no more. He died without the slightest pain, and his attendants, for some time, did not believe he had departed.' Joseph Gandy, in a letter to his son Thomas, added that: 'Ivano [his nickname for Soane] died as he wished without a sigh or a groan or struggle, in the arms of those who were leading him from the chair to the bed – after two days' illness....

He was with me quite healthy in November at Chiswick.' He was buried a few days later, after a private funeral, in the tomb in the burial ground of St Pancras where the remains of his wife and eldest son already lay.

19. Illustrations of just such coffins can be seen in Julian Litten *The English Way of Death: The Common Funeral Since 1450*, Robert Hale, 1992. This book shows just how typical were the arrangements for John's funeral.

EPILOGUE

SIR JOHN SOANE, KNIGHTED at the end of his career in 1831 by King William IV, had, in his last years, given thought to the permanent preservation of his house and collections, and had had an Act of Parliament passed in 1833, to come into effect on his death, vesting them in Trustees for the benefit of the nation as a Museum. The Act also appointed the first Curator, George Bailey, one of his architectural pupils and for many years his Chief Clerk, and the Inspectress, Mrs Sarah Conduitt, his Housekeeper since 1816. Together they ran the Museum until 1860, when they both died within a fortnight of each other in December. As Inspectress, Mrs Conduitt continued to visit the Museum several days a week, as she had done during Soane's lifetime, but George Bailey took up residence at No.13, the back bedrooms on the second floor and attic floor being appropriated respectively as a sitting room and bedroom for the Curator. Several of the servants who had been in Soane's employ at the time of his death were kept on, either to run the house, or in the case of the menservants to act as warders at such times as the Museum was open to the public. The Kitchens and other offices in the basement continued to be used to service the Curator's apartments.

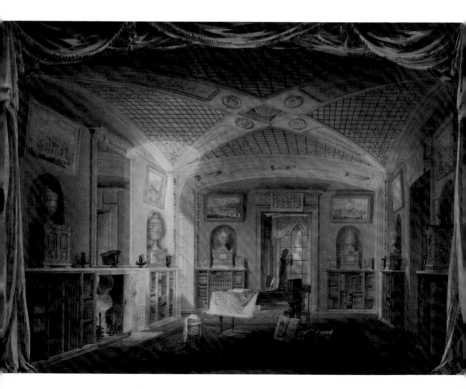

Subsequent Curators continued to reside in the house until after the Second World War when Sir John Summerson, newly appointed in 1945 to succeed Arthur Bolton, discontinued the practice. His predecessor had in fact only passed occasional nights in the Curator's apartments, having a family home elsewhere, and now, the basement of the house having been condemned as living accommodation, room had to be found for the Porter and his wife on the third floor, which rendered it impossible for a married Curator with a family to live in. From this date the rooms on the second floor became the administrative offices of the Museum. Now, after a major programme of restoration work, the private apartments on the second floor – Soane's Bedroom and Bathroom, the Model Room and Mrs Soane's Morning Room – can be seen once again as they were at Soane's death in 1837.

Under the Act of Parliament of 1833 and Soane's subsequent Will, No.12 Lincoln's Inn Fields continued to be leased out to provide an income for the upkeep of the Museum. With the slight alteration of some of the provisions of the original Act in a Charity Commission Order of 1969 came the opportunity for the Museum to take No.12 back into its control, and use it for much-needed office and library space. From that date, the two houses, though remaining separate, have been run as one, and visitors to the Museum have the opportunity to visit a number of the rooms in No.12. No.14 Lincoln's Inn Fields, built by Soane in 1824 to rent out for extra income, was one of the few properties to go to his family after his death, and therefore moved out of the Museum's control in 1837. Almost one hundred and sixty years later in 1996, the Museum was able, with a generous grant from the Heritage Lottery Fund, to reacquire the freehold of No.14, and, from 2008 to occupy the newly restored building, using it for Education, a Research Library and offices. The building is open to the public once a year on the Saturday of the Open House London weekend.

Design for the Library and Dining Room, Pitzhanger Manor, 1802.
Mrs Soane is dressed to go out walking; she is wearing a bonnet and holding a pair of gloves.
In the foreground can be seen her work-basket.

LIST OF ILLUSTRATIONS

ACKNOWLEDGEMENTS

My first thanks are due to my colleague Helen Dorey for generously sharing with me discoveries made during her research into the building over the last 20 years. I have had many enjoyable and illuminating conversations with Elizabeth Gabay on the subject of historic wines, and Peter Brears generously gave of his time to come and look at the Kitchen Range and other surviving domestic fitments and kindly allowed me to reproduce one of his drawings.

I am grateful to Tim Knox and Abraham Thomas, immediate past and present Directors of the Museum for their support for a new edition of this book and to Mirabel Cecil for all her encouragement. Lastly I should like to thank the team at Pimpernel Press for their help and guidance.

Susan Palmer
Archivist to Sir John Soane's Museum
December 2014